FANTASY PORTRAIT PHOTOGRAPHY

Creative Techniques and Images

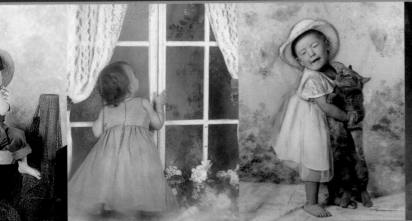

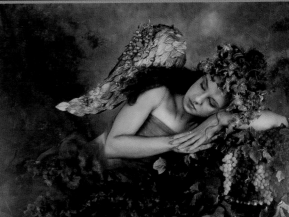

Kimarie Richardson

AMHERST MEDIA, INC. ■ BUFFALO, NY

*This book is dedicated to my late father,
Ron Richardson, and to my great aunt,
Olive Boughton. Creativity runs in the family.*

Published by:
Amherst Media, Inc.
P.O. Box 586
Buffalo, N.Y. 14226
Fax: 716-874-4508
www.AmherstMedia.com

Publisher: Craig Alesse
Senior Editor/Production Manager: Michelle Perkins
Assistant Editor: Barbara A. Lynch-Johnt

ISBN: 1-58428-124-3
Library of Congress Control Number: 2003103034

Printed in Korea.
10 9 8 7 6 5 4 3 2 1

table of contents

TECHNIQUES AND IMAGES
In this section, Kimarie Richardson reveals the techniques used to create some of her most popular and creative images. Each image is paired with descriptive text, found on the facing page.

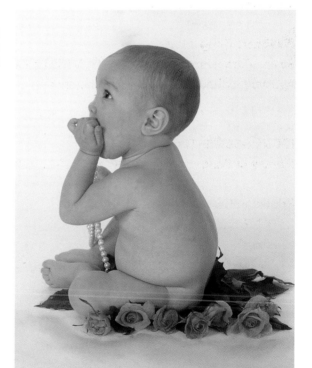

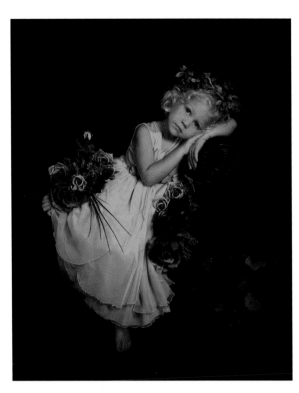

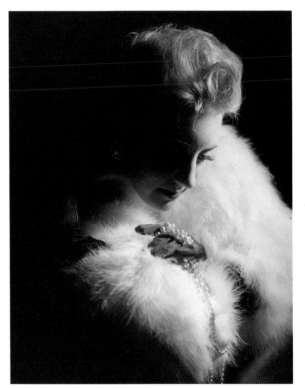

about the author

A decade ago, Kimarie Richardson never dreamed that she would one day be a professional photographer. In fact, she found herself in the perfect career after taking a series of wrong turns.

With an interest in working behind the scenes in the motion picture industry, Kimarie enrolled in a theatrical makeup school and learned how to transform actors into rough-and-tumble, bruised and scarred tough guys, and to pull out all of the stops and apply instant glamour through makeup. Though her talent flourished, Kimarie soon realized that gaining employment in the movie industry is no easy task. So, instead of realizing her dreams of creating the visuals that make silver-screen characters seem to spring to life, she found herself applying makeup for portrait clients at a big-business glamour photography studio. It didn't take long for her higher-ups to realize that she was management potential. To fulfill that role, Kim was supplied with camera training. This came easily to her, as the lighting setup, aperture, and shutter speed never varied from client to client.

In 1991, Kimarie decided to move on and applied for a job at a cosmetics counter in an

upscale department store in LA. When she was not hired, she was forced to reevaluate her career goals. Her friends were ready with a surprising suggestion: Open a glamour studio.

Kimarie stocked up on a wide variety of extravagant and fan-

ciful fabrics by the yard, scoured LA for high-impact jewelry, pulled out an old Nikon camera, then made a fateful move to Ukiah, a small town in northern California, to be nearer to family.

Soon after, a studio was born. Kimarie was immediately comfortable with applying her talents to make over her clients into striking, polished, and completely transformed individuals, coaxing them to really shine in front of the camera. Her work was an immediate success. Then came a favorable twist: Her many satisfied customers—not to mention prospective clients already familiar with her work—demanded that she diversify. They requested that she photograph their weddings, chronicle their children's growth, and photograph family groups.

As the pressure mounted, Kimarie realized that to grow her business and stay competitive—even in a small town—she would need to expand her repertoire and her vision. The self-trained artist purchased the necessary equipment, began to pore over books to pick up a few additional techniques, and decided she was ready for anything.

Today, the talented, award-winning artist can imagine no better career. She runs her business single-handedly and is not one to compromise her artistry and the image quality she provides to her clients for the sake of a big-business income. She easily transforms children into impeccably styled angels, complete with gilded wings, gossamer fabrics, and picture-perfect backdrops. She adds hand-painted embellishments to her unique portraits, making each carefully honed element of her one-of-a-kind portraits resonate further still. She also specializes in 1940s-style glamour portraits, carefully and artfully coifing hair and applying makeup, then

She transforms children into impeccably styled angels. . . .

bedecking clients with exquisite jewels, sumptuous furs, and in some cases, even a vintage cigarette holder! She creates storybook scenes for romantic weddings and artfully documents the finely woven bonds between the members in her well-orchestrated group portraits.

These days, Kimarie isn't resting on her laurels. The recipient of a Grand Award in the Premier category at the 1999 Wedding and Portrait Photographers Internal convention, she has shown the judges and her peers that her artistic zeal and unstoppable imagination know no bounds. When her

clients walk into Fantasy Stills Photography, they are in for a portrait experience like no other. They profit immeasurably from the individual attention they receive from this first-class artist, as can easily be seen in these pages.

special thanks

First and foremost, to the people of my hometown of Ukiah, as well as to those who reside in Mendocino and Lake Counties in northern California—especially the children. I extend my gratitude to all who I've photographed who trusted and supported me and watched me grow. So many of you have allowed me to step back into your lives—if only for a moment—to document your many special moments. I have established many friendships that will remain strong long after I put my camera down.

To Mom and Don, the most influential people in my life. Thank you for your many years of patience, for keeping me during my teenage years, and for letting me discover, over time, what I was put on this earth to do. I love you both.

To my lifelong friends; you know who you are.

To Bill Hurter, thank you for recognizing my work and for making me believe that I can walk side by side with the big guys. WPPI changed my life.

To the great staff of Snelson's Color Lab for the twelve years of beautiful printing—even when I didn't provide the best negative.

Unruh's Photography Shop provided over-the-phone photography lessons when I didn't understand the difference between f-stops and apertures. For your help, I am grateful.

And finally, to the true love of my life, Roley. Without you, this book wouldn't be here. Ninety-nine percent of the images in this book were created after you entered my life with such devotion and enthusiasm. I am today a better and stronger human being because of you. I know now what a true love really is, and I never want to walk without you beside me.

all in the family

This little girl came into the studio for a portrait session with her sister. When I finished photographing that grouping, I placed a roll of black & white film in the camera and positioned my lights low to keep the hat from casting shadows on my client's delicate features. To get this image, I had the girl sit on this faux tree stump and look down at her flowers. With that accomplished, I waited for this gentle, reflective mood to take hold.

quick reference

CAMERA
Mamiya 645 AFD

LENS
80mm

FILM
Kodak T400CN

APERTURE
f5.6

SHUTTER SPEED
$1/60$ second

camera selection

I shoot with a Mamiya 645 AFD—a medium format camera. I do not use my 35mm in the studio, since my medium format produces larger negatives and better image quality.

business basics

My studio is open for business from Tuesday through Saturday each week—except during the wedding season, during which I'm open only Tuesday through Friday. I require a deposit when a client calls to book a weekday session. However, if the customer needs to schedule a Saturday appointment, the session fee must be paid in full when the appointment is made. As Saturday is the most popular portrait day, and appointments are difficult to come by for many clients, I have found it necessary to provide a financial incentive for clients to keep appointments scheduled for that day.

My portrait clients come to my studio two or three days before their session. The consultation is especially important for my youngest clients. They need to become familiar with the studio atmosphere. Also, this ini-

. . . this initial meeting allows clients to get to know me.

tial meeting allows clients to get to know me so that I'm not a stranger when I pick up the camera. The timing is important. I want to conduct the initial meeting as near to the session as possible so that the discussions we've had and the excitement the client feels are still fresh when he or she arrives for the portrait session.

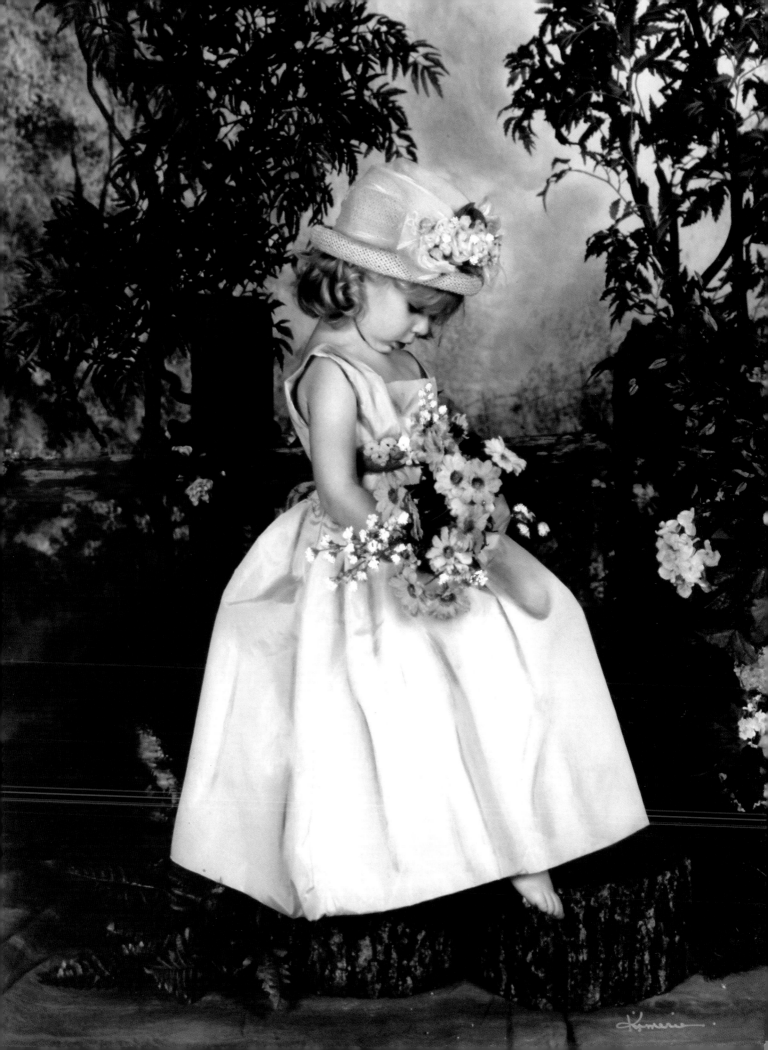

vintage style

Little boys and overalls go together like peanut butter and jelly. When this little guy arrived at my studio, he had a black eye, which, coupled with the clothing, made this shot speak volumes. In my mind, this image says, "I would ride a mile to apologize to you."

creating a concept

With kids, you simply can't wait for a smile; if you did, you'd wait a long time—and miss many great photo opportunities. Here, the overalls,

cap, and old-fashioned tricycle play a big part in creating a vintage-style image of a tough-

With kids, you simply can't wait for a smile.

as-nails kid who is all boy. However, the rose adds a softness that tugs at the heart of the viewer, creates intrigue, and adds warmth much like a smile.

the scene

A dark background worked beautifully for this shot. This particular muslin features a trompe l'oeil bouquet in the upper-left third that complements the single rose, adding a symmetry to the image and a line that draws viewers to the subject's face.

technically speaking

I used a vignette to soften the outer edges of the background, thereby drawing the viewer's focus to the real star of the

image—the handsome subject. Because I added this accessory to my lens, I had to shoot this boy's portrait with an aperture setting of f5.6 so that the vignette's pattern would not show in the image. Since I prefer to handhold my camera to allow for maximum movement when photographing children, I used a shutter speed of 1/60, which allowed for the capture of detail in the antique-style backdrop.

sepia toning

This image, like several others featured in this book, was sepia toned at the lab for a warmer, more old-fashioned look. After the image was toned, I hand-colored the overalls, the rose, and the hat for added impact.

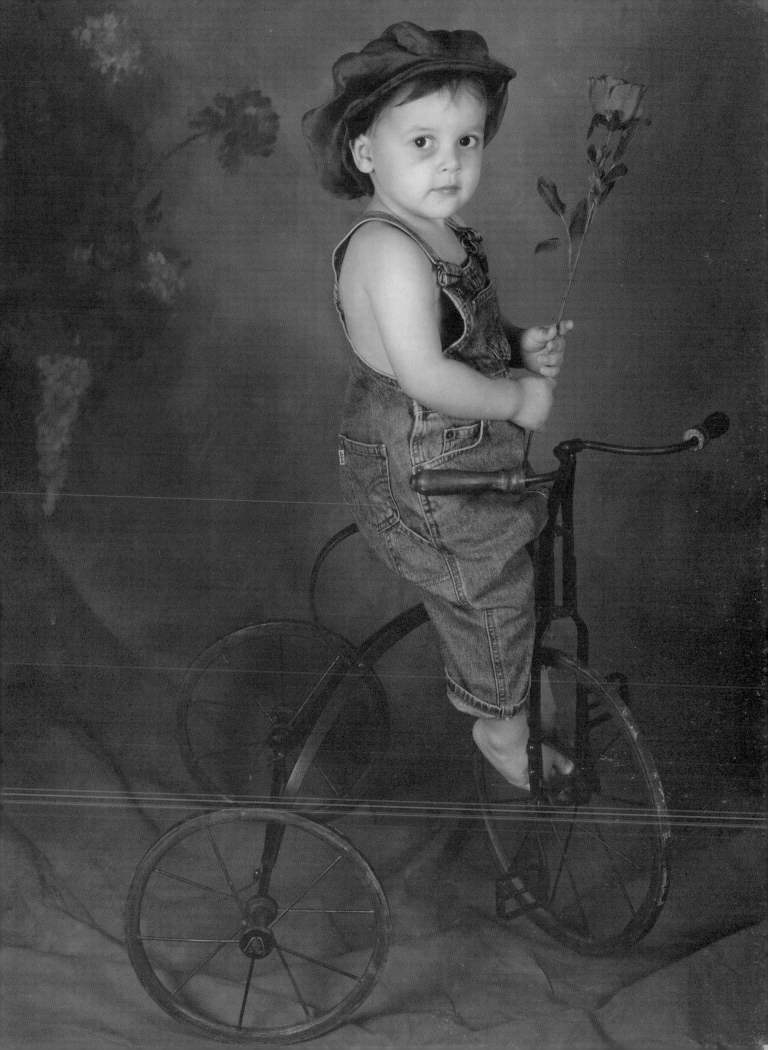

child's play

Little girls are always eager to play dress up. I curl their hair, add color to their faces, and often incorporate a few beautiful accessories—from flowers in their hair to a floral sash around the waist. These special touches go a long way, artistically speaking. They are also a real hit with my younger clients. A floral crown can easily transform a little girl into a princess!

I find children's feet beautiful and prefer to photograph them without shoes. I feel that bare feet add a wonderfully soft, timeless appeal, while shoes tend to date a portrait.

developing a concept

When my clients arrive at my studio for their portrait consultation, we discuss their clothing, the background selection, and the props. Sometimes, the concept is determined before the session; on other occasions, the full creative potential of an image is revealed only as the session unfolds.

The same props and backgrounds were used in each of these images. You'll notice that the overall color shifted from one image to the next with a change in the lighting and exposure. Flash was used to illuminate the top image, shot with an aperture of f5.6 at $\frac{1}{60}$.

In addition to using electronic flash, candlelight was an obvious light source in the bottom image. The slower shutter speed of $\frac{1}{15}$ allowed for more of the candlelight to permeate the scene; it also required my client to remain quite still.

The use of the candle, while it really makes the image stand out, proved to be a bit of a

A floral crown transforms a little girl into a princess.

challenge. As this girl was only five years old, having her sit back on her calves, with her dress and scarf carefully arranged around her, required a lot of practice. I had her take a deep breath, then exhale, so that I could time the shot to capture that moment when both she and the candle were perfectly still. Though I shot multiple images with the candle, I got only one perfect exposure.

quick reference

CAMERA
Mamiya 645 AFD

LENS
80mm

FILM
Kodak Portra 160NC

APERTURE
f5.6

SHUTTER SPEED
$\frac{1}{60}$ second; $\frac{1}{15}$ second

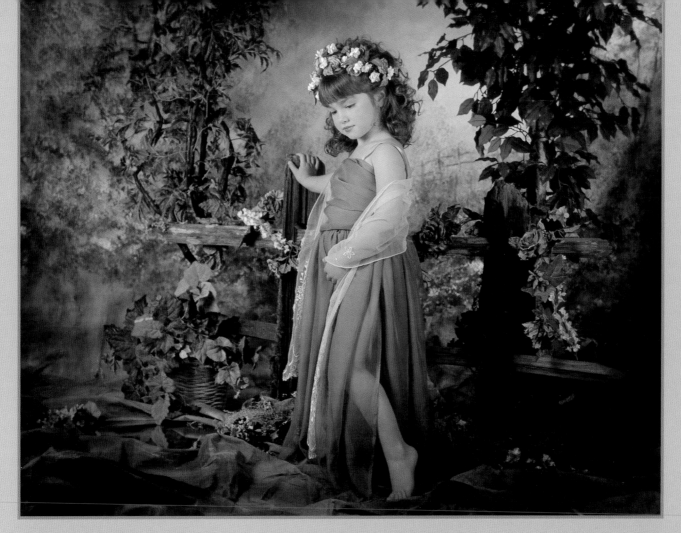

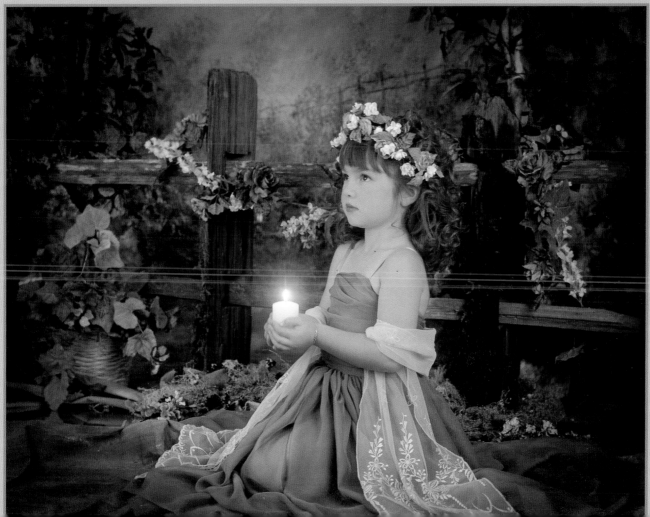

concept

Initially, this began as an Angel Babies portrait—a very gossamer, extravagant, and always hand-painted specialty portrait in which the child is depicted as an angel (see pages 54–67)—but the client didn't care for the wings! Despite that preference, we retained the other elements that make that image type special: her "dress" was made of white tulle, the background is soft and romantic, and the final print was hand-painted with Marshall Oils.

quick reference

CAMERA
Mamiya 645 AFD

LENS
80mm

FILM
Kodak T400CN

APERTURE
f5.6

SHUTTER SPEED
$^{1}/_{60}$ second

posing

I like to create a wide variety of poses when I'm photographing a client. After capturing this client standing, sitting in profile, etc., I went for this pose; it's my favorite of the bunch.

hand-painted portraits

Hand-painting an image adds value to your product. A lot of detail goes into the painted portraits. There may be 1,000 brush strokes in each image, and each image is unique. Portraits that will be hand-painted are printed on matte paper, as the paint tends to slide around too much on glossy prints. I offer hand-painting only on 11x14-inch or larger portraits, since it's difficult to paint in the same kind of detail on smaller images. I like to use Marshall Oils, as they have an appealing translucent quality. However, you can really use any oil paint on the market.

I generally sell this service after the session, when the client comes in to view their proofs. I show them a sample and say, "This can be yours." Then I tell them what it will cost. This is a real up-sell for

Images that will be hand-painted are printed on matte paper.

me. I rarely have clients come in with this particular option in mind. I tell customers that they are investing in an heirloom that will be passed on through the generations, and that their one-of-a-kind, hand-painted portrait will not be re-created for anyone else.

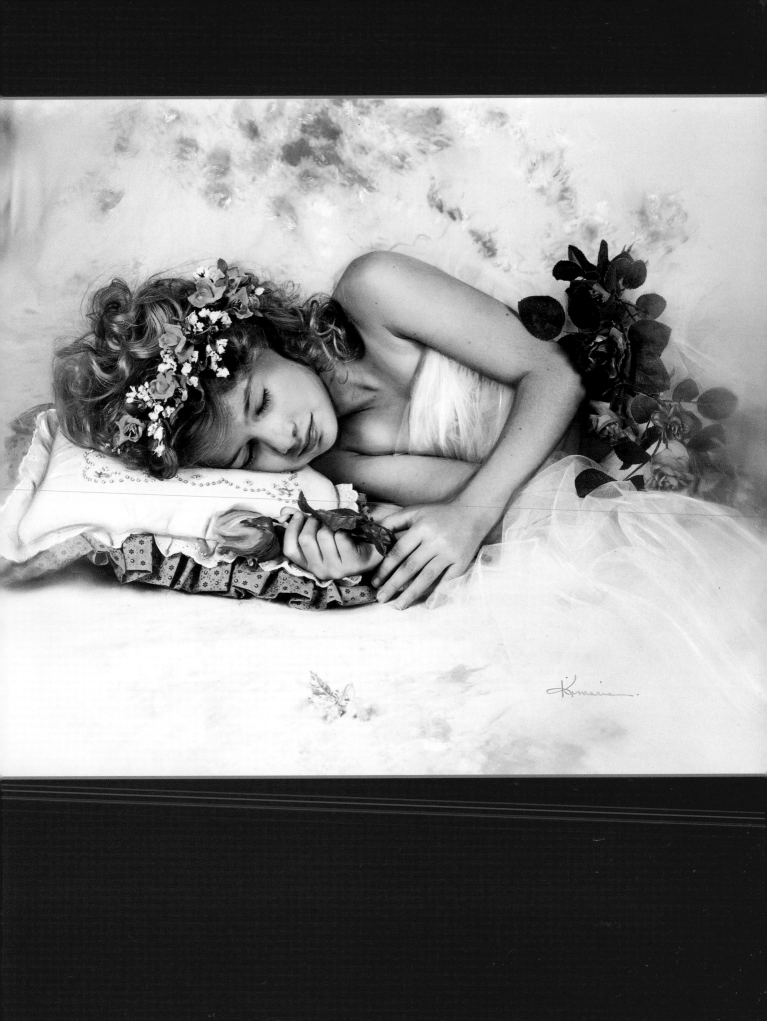

concept

This twelve-year-old girl wanted an image with a retro feel, reminiscent of the 1960s. She was very theatrical and had participated in many beauty pageants as a child. She had a lot of confidence in front of the camera, and fell into several great poses on her own.

use what you've got

As a photographer, you must think outside of the box. We are all limited to a certain number of backdrops and a certain amount of space. I've found that if you hold up your hand, make a circle with your fingers and thumb, and hold it

We are all limited to a certain number of backdrops. . . .

up to your eye, you can make a wide variety of architectural structures work to your advantage—for almost any session. While the structure might be surrounded by undesirable, distracting elements, just remember that you need not be concerned about anything that appears beyond the "lens" of your hand.

afternoon when the sun was at a low angle. This was fortunate, as this location lacked an overhang or any branches, obstructions that are often employed to block light in less-than-favorable conditions.

quick reference

CAMERA
Mamiya 645 AFD

LENS
80mm

FILM
Kodak T400CN

APERTURE
f5.6

SHUTTER SPEED
$\frac{1}{60}$ second

lighting

Direct, overhead light can create harsh, unflattering shadows on your client's face when shooting outdoors. In this instance, we were blessed with an overcast day, and the resultant soft, diffuse light. Additionally, the timing of this image proved advantageous; I shot the session in the late

special challenges

Orchestrating every aspect of a group portrait—especially when that group is comprised only of children—is always a special challenge. Taking a little time to get to know your clients can help you to keep them focused and can also help to bring out their personalities in the image.

In the case of the trio reading a storybook, having the eldest sister read to the younger children made my job easier. These children loved listening to sto-ries, and with their rapt attention, I was able to make minor posing adjustments and really capture a moment.

Some group sessions come together flawlessly, as did the one of the girls in overalls; others do not. In the example in the lower right-hand corner of the page, I wasn't able to capture an image where each of the subjects looked good simultaneously. I asked my lab to do a digital head switch for the client who is holding her bouquet, thus creating a well-executed composite. (While it is common for photographers to overinflate the cost of such a service, I charge my clients only what I am billed by my lab. I'd rather have my clients spend their money on my artwork and maintain the perceived value of my portraits!)

Although this change much improved the image, the color of the girls' dresses appeared washed out. This was remedied with the addition of a little hand-painting, which is seen throughout the image. In fact, each of these images was hand-painted. As you can see, hand-

I asked my lab to do a digital head switch for the client. . . .

coloring can be done on black & white and color images alike.

posing

Much of my posing is intuitive. When working with groups, I like to position my clients' bodies at an angle to the camera and create a certain rhythm in the portrait by making sure that clients' head heights vary. I position limbs in a way that will keep the viewer's eye moving across the image. In these images, a triangular composition supports these goals.

quick reference

CAMERA
Mamiya 645 AFD

LENS
80mm

FILM
Kodak T400CN; Portra 160 NC

APERTURE
f5.6

SHUTTER SPEED
1/60 second

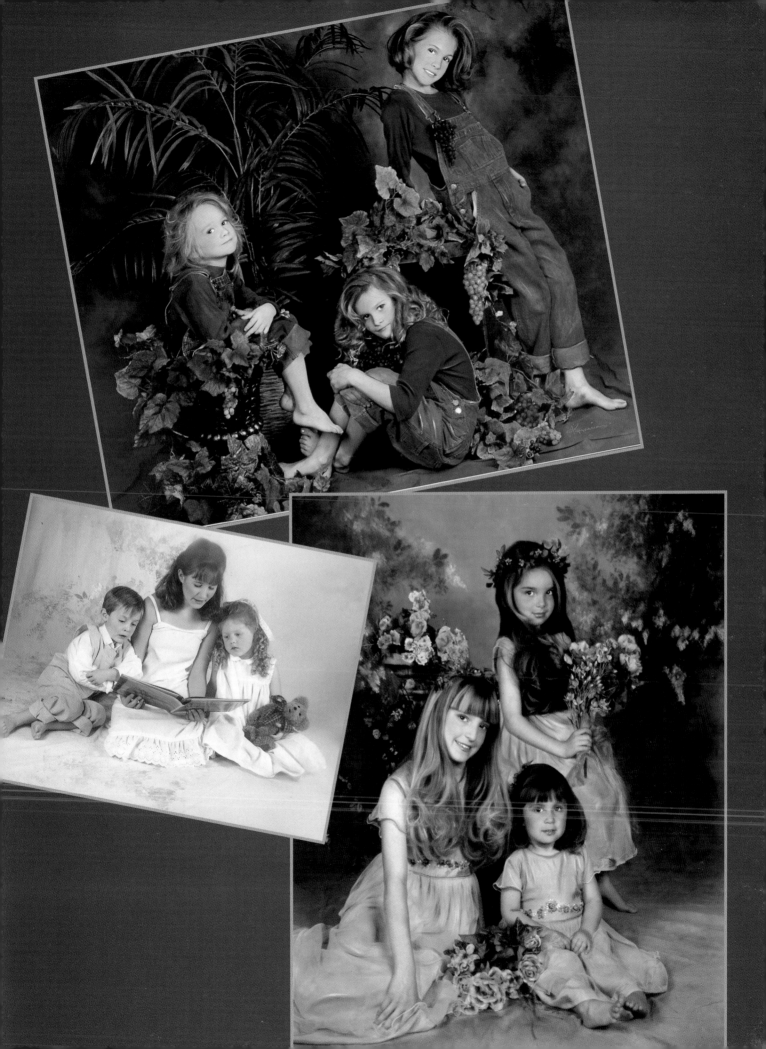

getting it right

Photographing children poses a number of challenges. When a pet is added to the mix, however, you'll find that those challenges quickly multiply. This particular pooch was especially energetic, and it took numerous tries to get the pair settled in this timeless pose.

Animals have minds of their own and, when they visit your studio, are often curious about their new surroundings. A parent or other companion is an indispensable aide when it comes to photographing a child-and-pet portrait. He or she usually has a rapport with the animal that you, as a stranger, will not. Placing the owner off-camera in the general direction in which you want the animal to look, and having him or her make soft noises to get the pet's attention, will produce the results you need.

concept

This image has a storybook quality to it; the classic clothing was well chosen, and the suede bandanna placed around the dog's neck illustrates the bond these two subjects share. You can just imagine the boy selecting it, calling his dog over, and the boy slipping it on. Sometimes the smallest additions to the portrait carry a lot of weight.

a word on props

Sure, you can browse antique shops for fabulous finds, but great props are also available through the many retailers who cater to photographers' needs.

The attention to detail lends an authentic quality.

Additionally, being creative—and handy—will stretch your budget and yield one-of-a-kind props. The fence pictured here was made by my fiance. The attention to detail lends an authentic quality. Notice the weathered areas of the fence and the moss that is "growing" around its base; both add dimension and realism to the image.

technical data

A fast shutter speed is essential in situations like these. For this portrait, exposure settings of $\frac{1}{125}$ and f8 did the trick.

quick reference

CAMERA

Mamiya 645 AFD

LENS

80mm

FILM

Kodak Portra 160NC

APERTURE

f8

SHUTTER SPEED

$\frac{1}{125}$ second

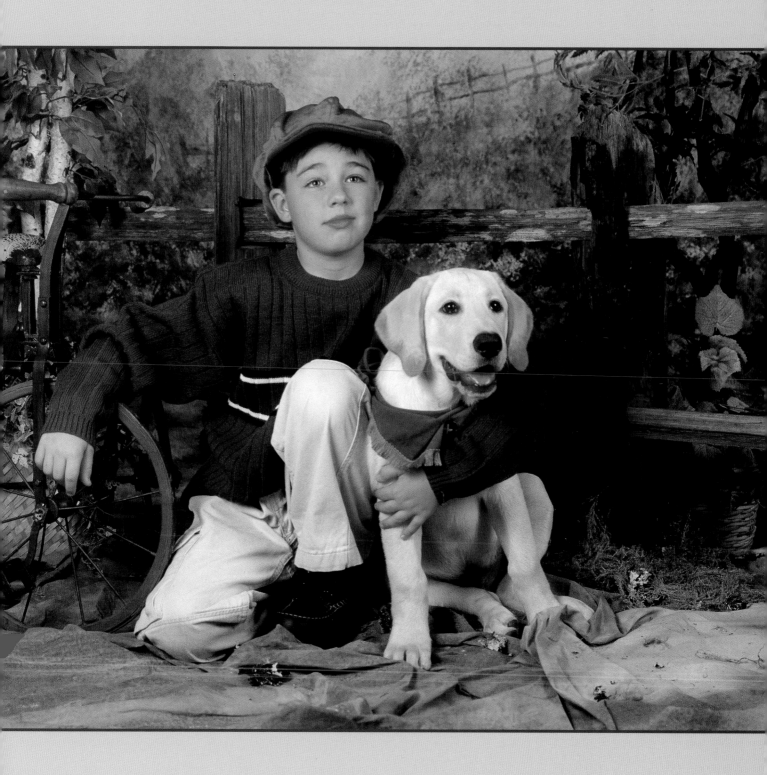

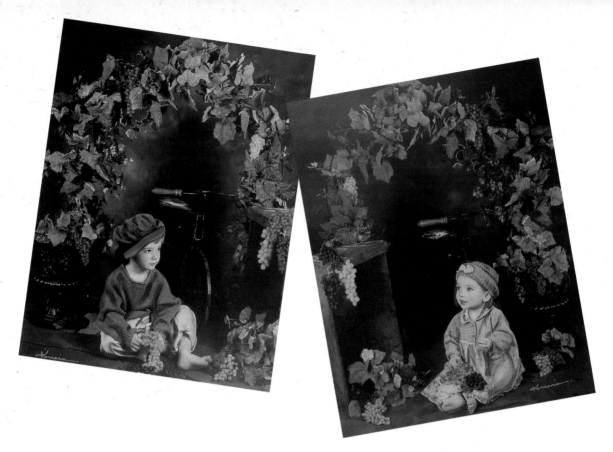

DOWN IN THE VINEYARD

concept

I work in northern California, where there are a great number of vineyards. For this rea- son, I've found that incorporat- ing grapes vines as props adds a local interest in my images.

When it came time for this ses- sion, the clothing that the mom brought in to the studio really fit the bill; the autumnal colors and interesting textures blend well with the background ele- ments to produce an old-world, vineyard-inspired mood.

technique

To create the group portrait on the facing page, I set my aper- ture at f8 and used a shutter speed of $\frac{1}{60}$ to ensure sharp focus across both planes of focus occupied by the kids.

For the "solo" portraits, I used the same exposure settings. However, each child was ori- ented differently, adding vari- ety to the image grouping.

Marshall Oils were used to deepen the tones in various ele- ments in the image, yielding an old-fashioned, moody tone in the image.

quick reference

CAMERA
Mamiya 645 AFD

LENS
80mm

FILM
Kodak Portra 160NC

APERTURE
f8

SHUTTER SPEED
$\frac{1}{60}$ second

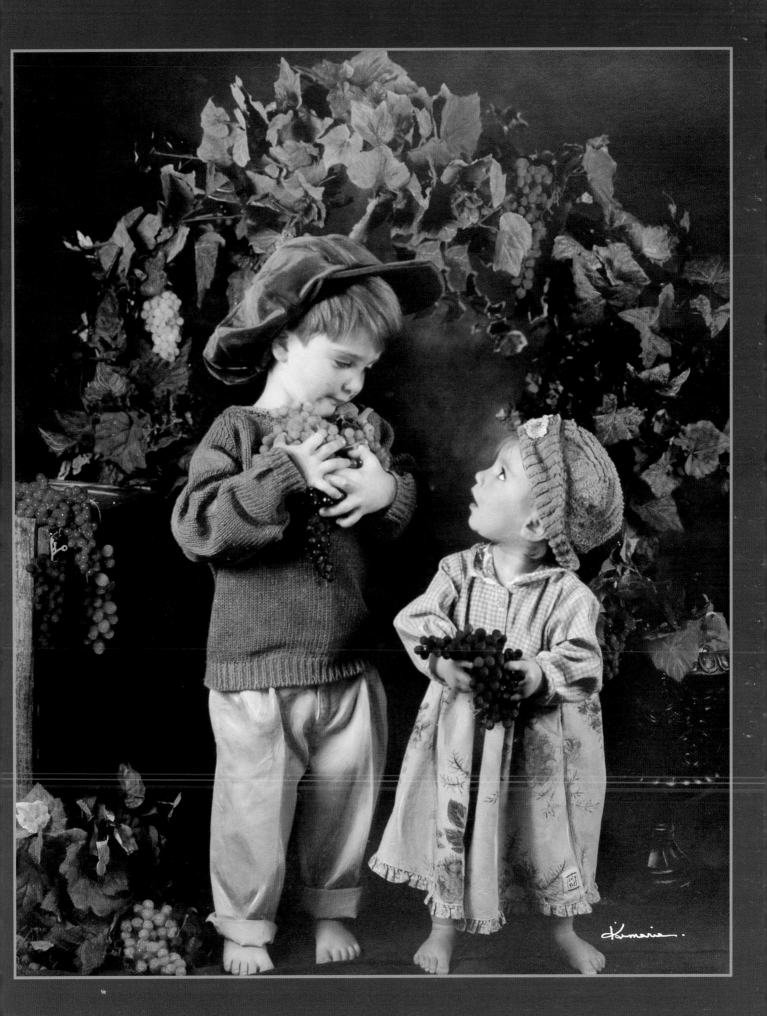

the old and the new

Here is an image where tradition meets technology for a great effect. Peaches was being less than cooperative, and instead of lying near Sophy, as was our intention, he decided to exhibit his independence and took off toward the edge of the backdrop. When Sophy rushed to gather him up, I snapped the shutter—even though she had already moved past the painted backdrop. This is another in-stance where a fast shutter speed allowed me to capture a precious—but

fleeting moment. I later took a photo of the background and had it digitally added to create this seemingly perfectly posed portrait of the two.

When photographing children, I shoot only handheld exposures, as I don't want a tripod to restrict my movement. With

and played up Peaches's eyes and "smile." As hand-painting predates color film emulsions, I think the hand-coloring contributes to the vintage feel of the image.

backdrops

Most studio owners invest a lot of money in backdrops. If

Here is an image where tradition meets technology. . . .

very active children—especially when animals are involved—I also plan for a fast shutter speed. In this case, an f8 aperture and a shutter speed of $1/125$ allowed for the capture of detail in Peaches' fur and Sophy's dress and hat; it also offset any possible blurring from camera shake.

While this image was captured in black & white, I thought it would benefit from some hand-painting. I added color to Sophy's cheeks, lips, and dress,

you don't currently have one, installing a tracking system like the one manufactured by Ontrax will help you to keep your backdrops organized, readily available, and relatively wrinkle-free. With this track system, the backdrops are gathered at one end, and you pull the one you need into position along the track. Wrinkles can be "ironed out" with an industrial-type clothing steamer. I purchased mine for about $120.00, and it truly works wonders.

quick reference

CAMERA
Mamiya 645 AFD

LENS
80mm

FILM
Kodak T400CN

APERTURE
f8

SHUTTER SPEED
$1/125$ second

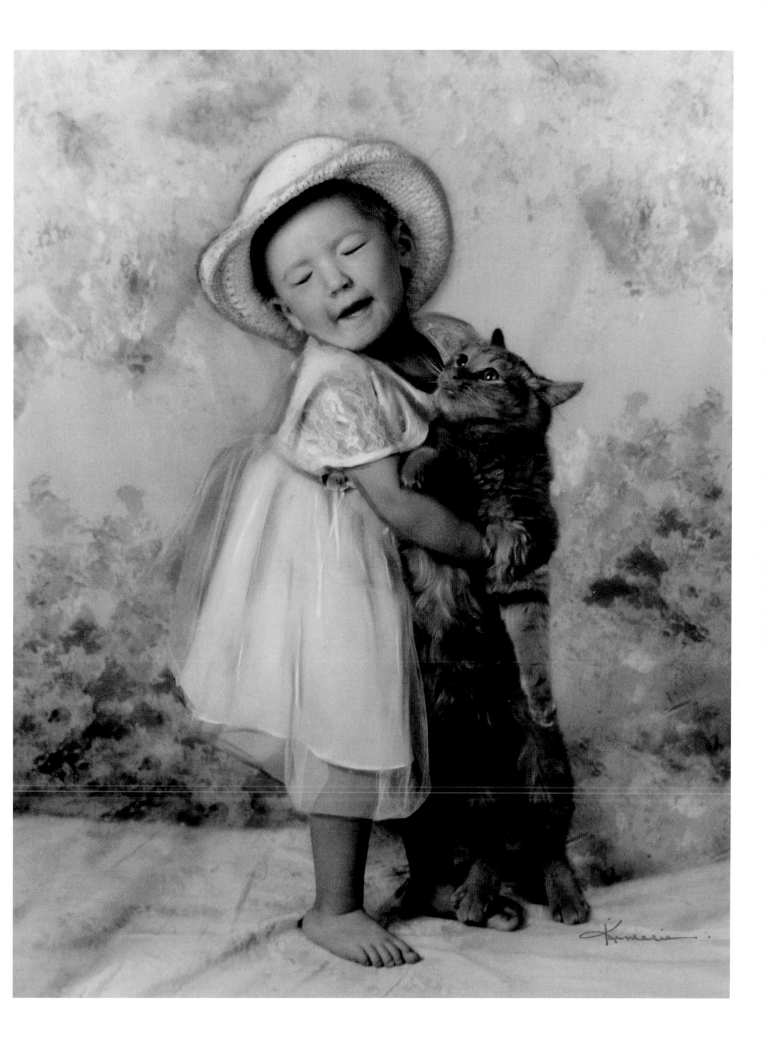

WOODLAND LIGHT

concept

This image is decidedly similar to the ones pictured on page 13 for a good reason: this client's mom saw the other images and wanted to re-create the concept in her daughter's portrait.

While many of the elements remain the same, the color in this image varied from that of its inspiration. In this case, I used modeling lights with a slow shutter speed rather than a fast shutter speed with electronic flash. This resulted in the darker, richer tones seen in the background. An application of Marshall Oils to key elements in the scene intensified the mood.

filters

While I sometimes use a soft-focus filter when photographing older clients, I rarely use filters when photographing children. In this case, however, I used a four-point star filter to get the diffraction on the flame of the candle that the subject is holding. Because the same effect repeated on the second candle proved to be a bit much, I had the lab remove it.

This filter was once very popular in wedding photography (you may vividly recall altar photographs featuring candelabra with these special-effect flames). While its use in that realm now makes an image appear dated, it is wonderfully suited for a fantasy portrait!

quick reference

CAMERA
Mamiya 645 AFD

LENS
80mm

FILM
Kodak Portra 160 NC

APERTURE
f5.6

SHUTTER SPEED
$\frac{1}{15}$ second

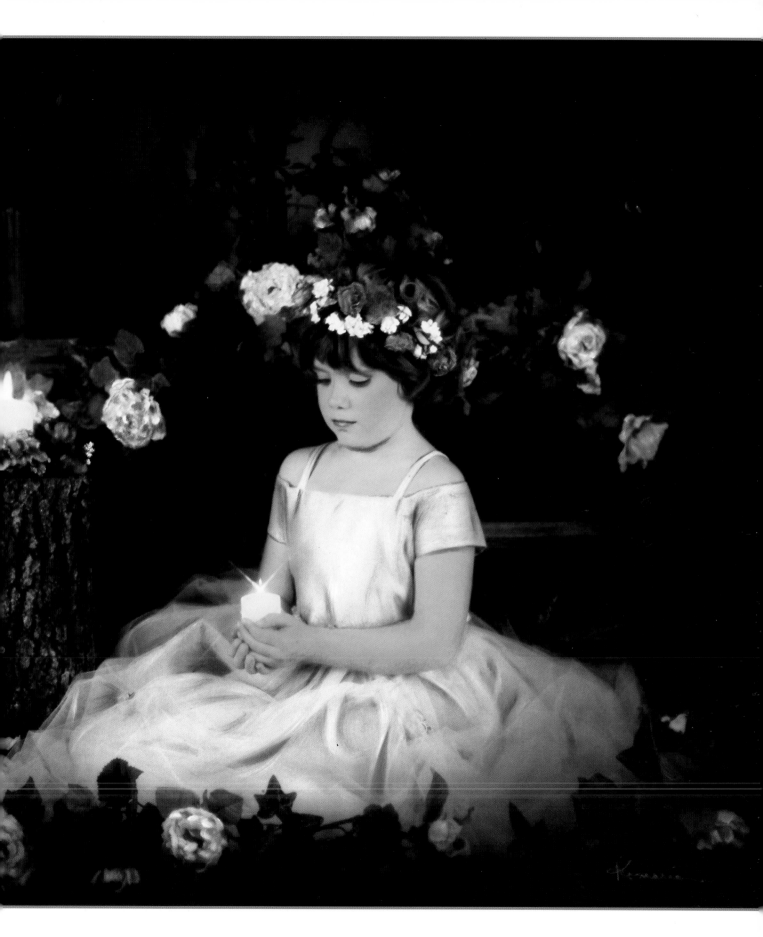

posing groups of two

One of the primary motivations for many parents in getting a professional portrait made is to "freeze" time.

As you can see, the three images on the facing page feature a variety of poses that capture a moment and illustrate a strong bond between the clients. There's no need to rely upon the same poses every time you photograph a client; in fact, if you observe your clients' interactions, you're likely to come up with some fresh, utterly natural-looking poses, which can be finessed for a stronger visual appeal.

clothing selection

I advise my clients to avoid clothing with bold patterns and logos. These always draw focus away from the main area of interest in a portrait—the client's face.

Since all tones in black & white photographs shift either toward white or toward black, matching colors in grayscale images is not a primary concern. For instance, while the girls in the upper-left image appear to be wearing well-matched white dresses, one girl is actually dressed in pink. If, despite your recommendations during the client's consultation session, your subjects arrive in clothing that doesn't lend itself to the type of image you'll be creating, shoot the image in black & white—if they're longing for color, you can always offer a hand-painted portrait (and command a greater profit!). On the other hand, with

I advise my clients to avoid bold patterns and logos.

the selective color-swapping opportunity available in Photoshop and other digital imaging programs, poor color combinations can be easily corrected, whether in-house or through your lab.

quick reference

CAMERA
Mamiya 645 AFD

LENS
80mm

FILM
Kodak T400CN; Portra 160 NC

APERTURE
f5.6

SHUTTER SPEED
$\frac{1}{60}$ second

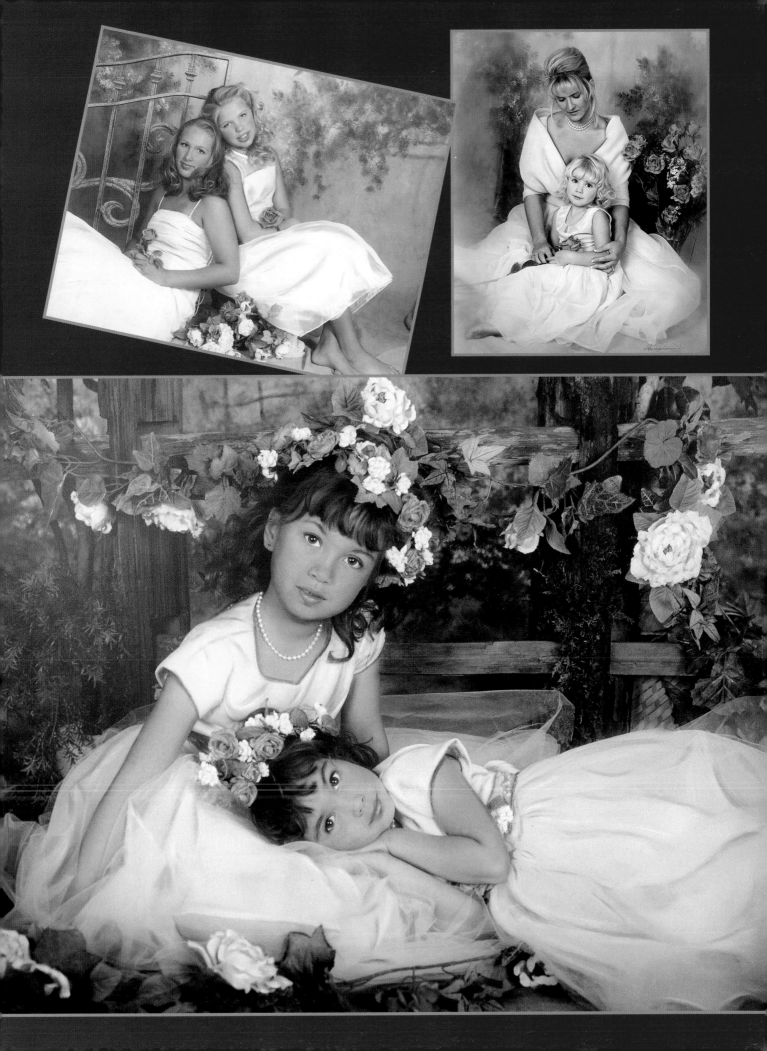

taking a chance

Sometimes a concept is born before the right kid comes along who will suit that theme perfectly. I had envisioned a Huck Finn–type image and began to compile the elements necessary to bring that portrait to life. I commissioned a friend to build and paint this giant, seven-foot-moon, then drove out to the country to load it into my truck. As luck would have it, a big gust of wind sent my newly-constructed moon sailing. Fortunately, despite the tumble it took, it was no worse for the wear. I brought my new prized prop back to my studio and prepared to put it to use.

Compiling the materials necessary to develop this scene came easily to me. My fiancé made a very handsome dock, which makes a cameo appearance in the right-hand corner of the frame. The rubber fish was purchased for under two dollars at a local store.

With everything from concept to props prepared for my long-planned image, I asked a friend if I could photograph her red-headed son—free of charge—to take this set for a test drive. Fortunately, she happily obliged.

On the day of the session, I created several poses, then asked "Huck Finn" to place his hand against his cheek. The resulting expression was priceless.

For added impact and a heightened storybook feel, I hand-painted the major elements in the scene.

boys vs. girls

Fantasy portraits of boys are a little more pared-down than

Sometimes a concept is born before the right kid comes along.

the ones I typically create for young girls. Well-chosen props, classic clothing, and storytelling expressions are the main components of a more masculine children's portrait.

quick reference

CAMERA
Mamiya 645 AFD

LENS
80mm

FILM
Kodak T400CN

APERTURE
f8

SHUTTER SPEED
1/60 second

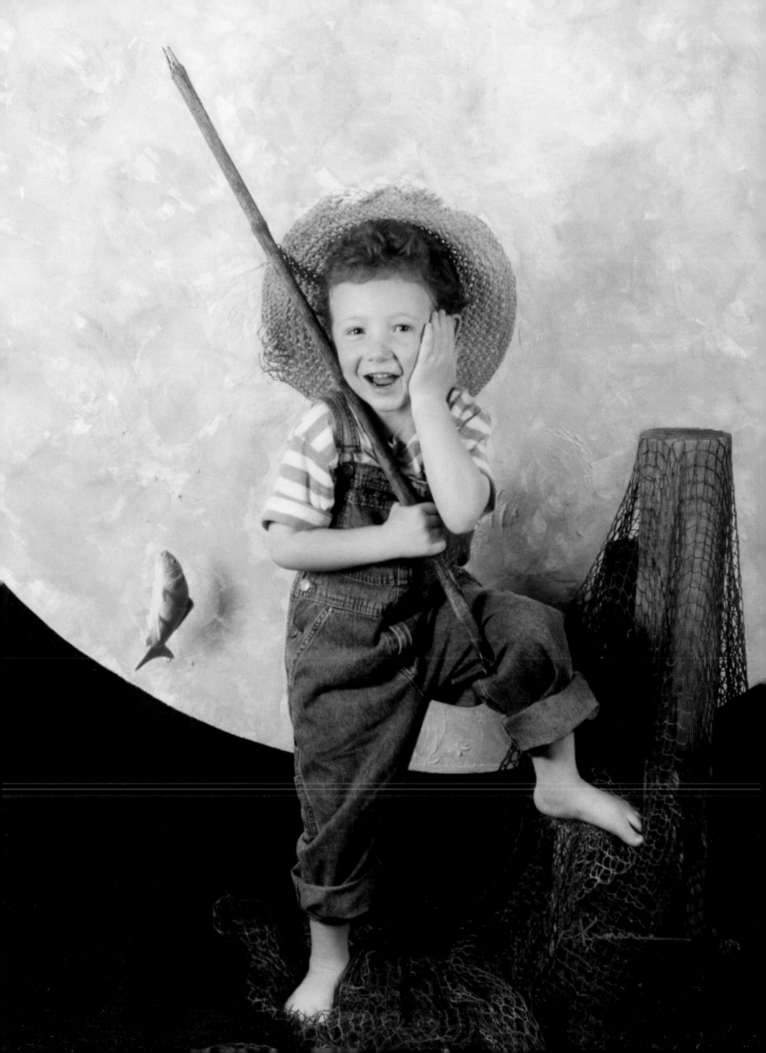

in all seriousness . . .

It can be difficult for a parent to loosen up on the reins and turn control over to their child's photographer. After all, the parents of any client generally come in to the studio with a preconceived set of expectations, often garnered from poor previous department store–type portrait experiences and posed family snapshots. One of these expectations is that a child should be facing the camera and smiling. Another is that a child's portrait should be in color.

quick reference

CAMERA
Mamiya 645 AFD

LENS
80mm

FILM
Kodak T400CN

APERTURE
f5.6

SHUTTER SPEED
$\frac{1}{60}$ second

A good photographer knows when breaking with tradition will ultimately create more engaging images. I often like to take what I call "interac-

I often like to take what I call "interactive" portraits. . . .

tive" portraits, ones that capture a child exploring and learning about an object in his/her portrait environment. With shy children especially, I've found that using the longer 80mm lens, standing quite removed from their personal space, and watching the scene "unfold" is usually the perfect pictorial remedy.

This girl was quite taken by the flowers, though she is definitely not smiling. Instead, she is deep in thought and in full profile. Don't be afraid to capture various facets of your subject's personality. After all, capturing serious, nonsmiling images will often appeal to parents, though some may be a bit reluctant to give the concept a try. Parents love their children whether smiling, in tears, or sleeping peacefully—so why not create images that capture their many moods?

Though serious, this little girl exudes a softness that is well-supported by the sepia tones I chose for this portrait. While the toning was done through my preferred lab, Snelson's Color Lab in Springville, Utah, I did the hand-coloring myself. I chose soft, yet vibrant shades that play well against the brown tones in the image. With the beautiful depth of tone, warmth, and gorgeous color employed to create this image, the original black & white print really takes on a new dimension.

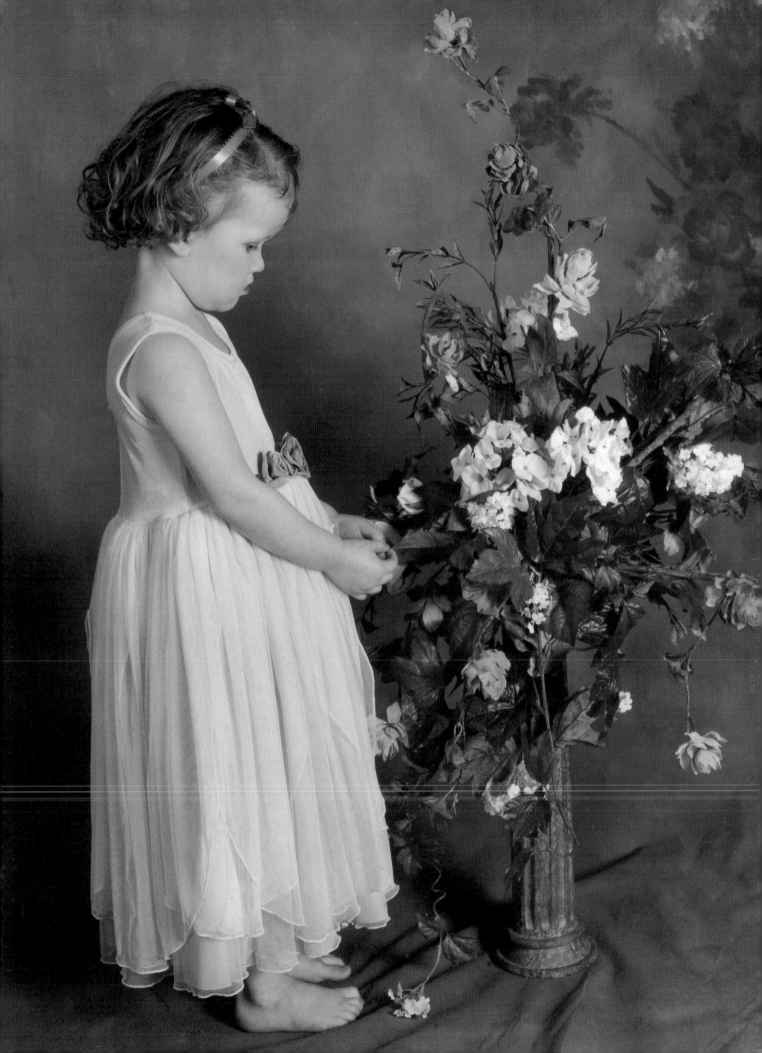

thematic portraits

In California, you're likely to photograph a child from a family of vintners at some point in your career. This theme portrait was developed for just this reason.

making it fun

Small children can think of many things they'd rather be doing than posing for a photographer. This little guy was looking for additional entertainment during the shoot—as small children are prone to do. Instead of fighting that

quick reference

CAMERA
Mamiya 645 AFD

LENS
80mm

FILM
Kodak Portra 160NC

APERTURE
f5.6

SHUTTER SPEED
$\frac{1}{60}$ second

impulse, I asked him to begin piling the bunches of grapes into the crate. As it turns out, this simple request helped to turn a challenging situation into a great photo opportunity.

stock photos

I am very fond of images that do not feature a child looking

Portraits of this type sometimes have a more universal appeal. . . .

head-on into the camera. To me, portraits like this one really put an emphasis on the child's developmental stage and show a lot of personality. Some customers love these aspects, while others—no matter how you try to convince them of the merits of the style—will accept only head-on, smiling pictures of their kids.

An advantage of producing portraits of this type is that they sometimes have a more

universal appeal. While an individual might be reluctant to display a photo of a stranger in her house, she appreciates the anonymous quality of the partially hidden face in images like this one and the one pictured on page 51. Such images are natural choices for stock photography markets, where anonymity can have a particular appeal.

clothing

I am always looking for clothing and other props that will set my images apart. While the Internet offers many advantages for photographers, in my mind, shopping is not one. I like to see everything in person, to ensure that I can best gauge its quality, visual weight and size, etc. Sometimes, such details are diminished online.

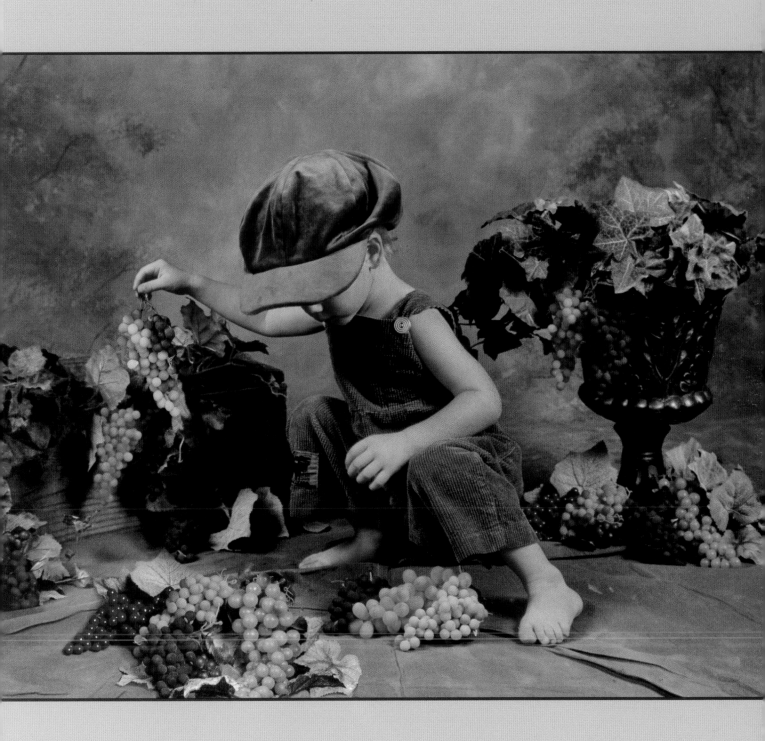

hair and makeup

Though only three-and-a-half years old, this little girl was truly looking forward to her portrait session. When I began curling her hair, however, I realized that she wouldn't much enjoy the downtime associated with waiting for the hot rollers to cool down and the curl to take. I made good use of the time by adding very light, and by all rights, "invisible" color to her cheeks and lips. Consequently, she felt pampered to the point that she forgot to fidget!

quick reference

CAMERA
Mamiya 645 AFD

LENS
80mm

FILM
Kodak Portra 160 NC

APERTURE
f5.6

SHUTTER SPEED
$\frac{1}{60}$ second

deja vu?

No photographer has unlimited means when it comes to equipping a studio. A wise person once said, "It's not what you've got, it's how you use it." This image offers a prime example of that philosophy. You'll see the same clothing and visual elements used in other photos throughout this book; and although the pieces are the same, the end results vary greatly—by design.

As I mentioned previously, good clothing choice is essential to getting a good shot. This dress has a very soft, classic quality; it does not date the image and, as it does not feature logos or a bold pattern, it only enhances the girl's beautiful expression. Note how the floral accent at the waist is echoed in the headpiece, as

well as in other areas in the image.

posing

With children, you can often coax a great pose easily just by making a simple suggestion.

Good clothing choice is essential to getting a good shot.

Because most young children haven't developed the self-consciousness that generally plagues adults, their poses appear very natural. Here, I positioned the little girl so that she was sitting on one tree stump and had her feet resting on another. I then gave the simple directive, "Hug the flower," and this was the result!

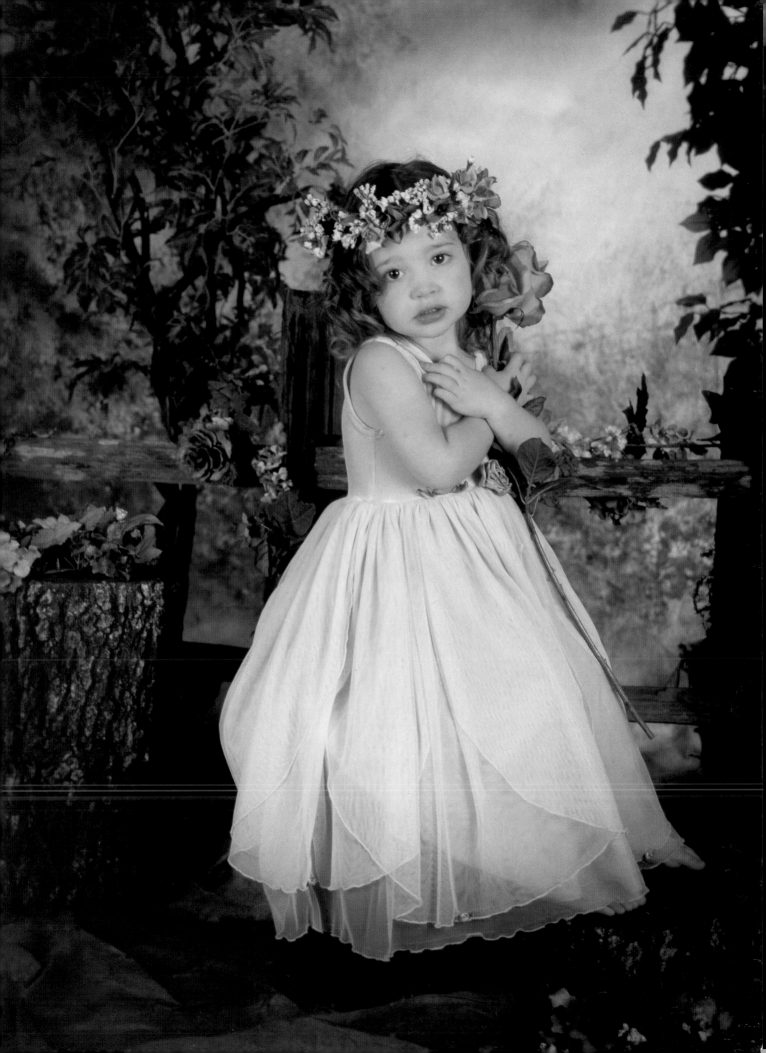

concept

Try as you might, sometimes a clever new concept just won't present itself. Other times, it's as plain as day. And on some occasions, you'll find that the client has the best possible solution.

When this little guy's mom called to express her interest in having a portrait made, I asked her what type of photo she had in mind. She said, "I don't know. His last name is Lemons. I could bring in a bag of lemons. . . ." Voilà, another

quick reference

CAMERA

Mamiya 645 AFD

LENS

80mm

FILM

Kodak Portra 160NC

APERTURE

f5.6

SHUTTER SPEED

$1/60$ second

concept was born! Of course, they don't always come quite so easily.

setting the mood

While a floor strewn with lemons doesn't tell a story, a few additional props really pulled this concept together.

The box was lined with cotton for increased comfort. . . .

When the clients showed up at my studio for the portrait session, there was another pleasant surprise: the mom had the foresight to paint "lemons" on a wooden crate appropriate for the little roadside fruit salesman. This was a great addition to the portrait, as it reinforced the theme of the image and added texture and dimension to the scene. The same feel simply could not have been achieved without this crate, because the remaining props—the lemons and ivy—did not carry substantial visual weight. The box

was lined with cotton batting for increased comfort and to give my small subject height and improved prominence in the scene. The ivy added a dose of color and additional texture and interest in the foreground. He looks like a little salesman, ready to peddle his wares. The

hat—and his earnest sales pitch—appear to be borrowed from a doting, old-world dad.

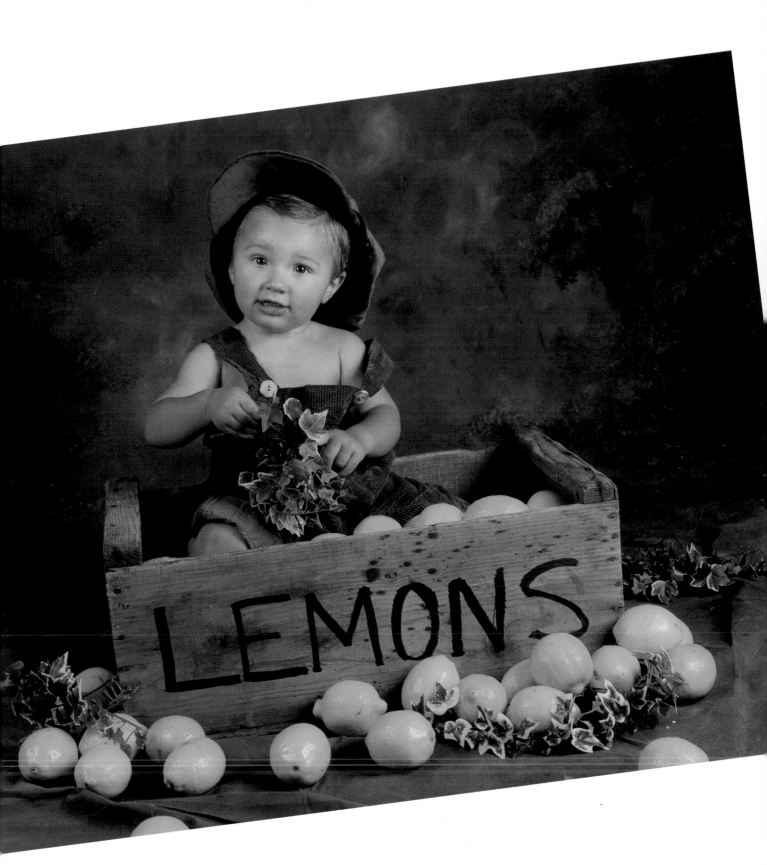

mood

There's no doubt about it: when the time came to take this photo, my subject was just tired out. Oftentimes, when children have had enough, you'll find that your artistic returns on your investment just aren't panning out. However, with the props and background used in this image, my client's mood further emphasized the storybook quality of the image.

Katie seems to have found a remote corner of a garden in which to rest; and you can imagine a grown-up coming to pick her up and carry her down the winding garden path to her home.

coloration

This pretty portrait was taken with Kodak T400CN, a color-process black & white film. In

remember, a classic piece of clothing can go a long way in helping to establish mood in an image, without taking center stage.

In this full-frontal pose, the roses that adorn the waist of the dress tie in with the climb-

When the time came to take this photo, my subject was just tired.

black & white, however, the print lacked warmth. A sepia toner was used to achieve the warm brown hues and creamy whites that help to carry the mood. I selectively added in color, which is most apparent in the rose; in this case, the viewer's eye is attracted first to the girl's face, then to the flower, which redirects the viewer's gaze to the subject's face once again.

You'll note that this is the same dress worn in two previous images (see pages 32 and 36);

ing roses that seem to have claimed this swing as a kind of trellis.

quick reference

CAMERA

Mamiya 645 AFD

LENS

80mm

FILM

Kodak T400CN

APERTURE

f8

SHUTTER SPEED

$^1/_{60}$ second

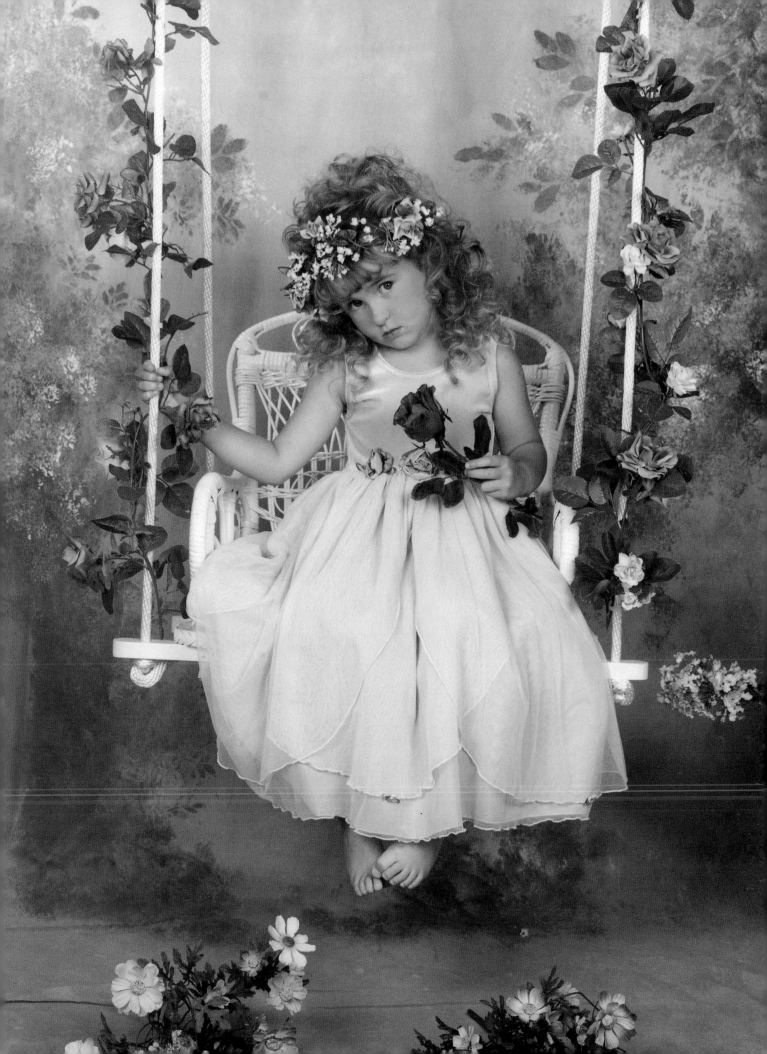

SHHH . . .

parental involvement

Parents love to watch their child's portrait session unfold. They often offer input and try to coax wide, toothy smiles out of their children. While parents may see this involvement as well-intentioned, in truth, it often distracts clients and can actually be a detriment to achieving a successful portrait session.

If you think the parent is distracting your client, politely encourage them to allow you to conduct the session one-on-one. In this case, the girl's mom left my camera room to feed her youngest daughter. I was then able to coax this "sleeping" pose. Her relaxed demeanor shows in this very natural, tension-free pose.

possibilities

Pictured to the left is an image of the client before her fantasy makeover. While the clothing and props seen in the final portrait really suit the client's beautiful coloring, it's clear that the hand-coloring takes the image to another level. You can see what an impact hand-coloring can have—even on a color image!

quick reference

CAMERA
Mamiya 645 AFD

LENS
80mm

FILM
Kodak Portra 160 NC

APERTURE
f5.6

SHUTTER SPEED
$1/60$ second

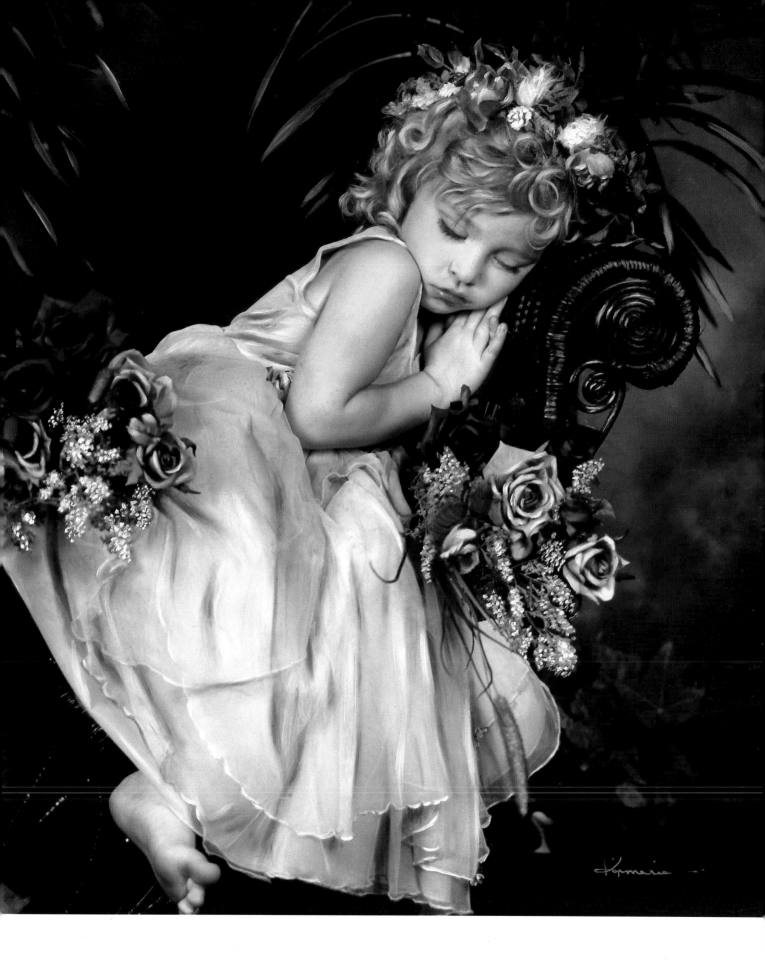

theme

This image concept came from this little guy's mom, who had a very special and quite specific end-product in mind: this portrait was to be featured on my customer's wedding invitation!

The props used here were few and were really quite simple—a wicker bench, a stack of newspapers, and a rolled newspaper "scroll," neatly tied with a black ribbon. The subject's mother arrived at the studio with this perfect little outfit in

hand; it could not have been better suited to this vintage-style portrait theme.

This image is solid proof that you don't need to spend a lot of money on props to make story-

This photo was to be featured on my customer's wedding invitation!

telling images. In fact, with a keen eye, you can find a variety of interesting elements that cost next to nothing, or in some cases, are free for the asking!

I took several photographs of the boy in a wide range of poses—sitting on this bench, standing on a log, etc. When the proofs came back from the lab, we liked this image best. Unfortunately, the topmost newspaper in the stack featured an inappropriate headline that appeared at the bottom of the image. Since I use an 80mm lens to physically remove myself from the client,

I was able to crop out the offending headline and thus save the image!

The client's mom took this portrait to a local print shop, where the custom wedding invitations were created. What could be more special?

quick reference

CAMERA
Mamiya 645 AFD

LENS
80mm

FILM
Kodak T400CN

APERTURE
f8

SHUTTER SPEED
$1/_{60}$ second

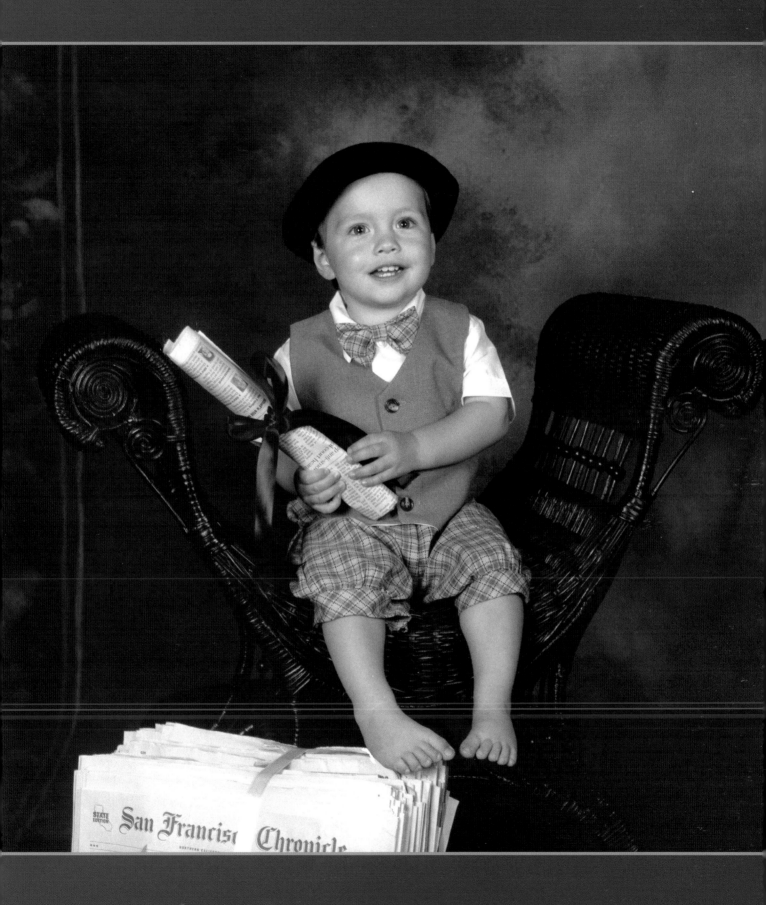

texture

Texture is an important element in a portrait. Here, the client's dress (a studio staple) has a luminous quality both in its color and its sheen. The artificial tree stump and rugged fence provide a lot of visual interest in the image as well.

Color plays a supporting role in this image. The colorful floral garland, which visually encircles the portion of the image occupied by the subject, carries the viewer's eye through the frame but ultimately holds the viewer's attention on the lovely subject.

Since the textural props are neutral, the flowers add some needed punch to the otherwise earth-toned elements in the scene. With the dark, shadowy trees on the painted backdrop and the layering of props from the back to the front of the scene, I've created the illusion of a great deal of depth in the final image. With an open mind and a creative eye, you can create a whole new world in even the smallest of camera rooms.

in retrospect

This little girl's parents didn't have any particular preference for the style of image I would create and, as such, I devised this setup on my own. As it turns out, this family's sensibilities tend to the modern—and this is a decidedly country-style image. While this image was a hit, it just goes to show how important it is to glean

Texture is an important element in a portrait.

information about your client's lifestyle in order to best create an image that is well suited to their decor.

quick reference

CAMERA
Mamiya 645 AFD

LENS
80mm

FILM
Kodak Portra 160NC

APERTURE
f5.6

SHUTTER SPEED
$^1/_{60}$ second

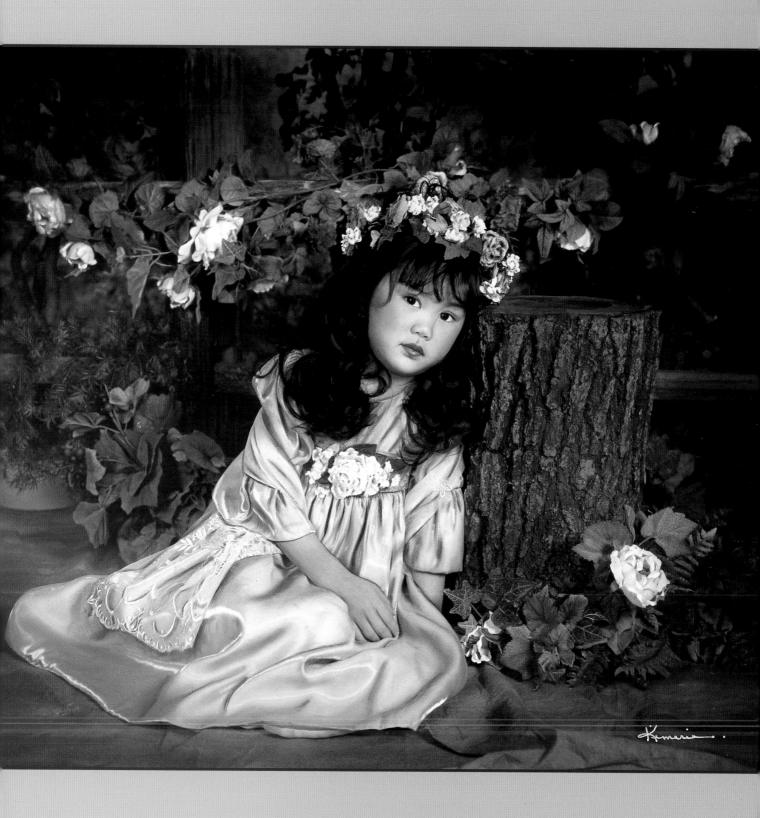

background check

This image was taken in the midst of October, and the fall season plays an important role in setting the tone of the image.

Here, the background is an old Victorian-style house in the neighborhood. I knew that the stone steps would add the rustic, antiquated feel I was looking for in the image.

As the portrait was shot in black & white, all of the deep, intense, autumnal colors you see in the scene were added with Marshall Oils. Again, while you can use any oil paints when hand-painting your photographs, these have a translucent quality that I find especially appealing. Just look at the color on the girl's lips. It's hard to believe that it came

quick reference

CAMERA
Mamiya 645 AFD

LENS
80mm

FILM
Kodak T400CN

APERTURE
f5.6

SHUTTER SPEED
$\frac{1}{60}$ second

out of a paint tube; it looks, instead, like the girl just applied her favorite lip gloss in preparation for a very important play date!

getting it right

I will do whatever it takes to ensure that my clients are happy with the outcome of their portraits. While this session began in-studio, with a dress that the mom had brought in, I soon realized that the added pearls and hat would complete the look. It then became apparent that the en-

semble would be well suited to this on-location scene.

timing is everything

Some photographers—especially those working in large, commercial chains—must adhere to a strict time frame when photographing clients.

I'm not interested in a revolving-door-type schedule.

I'm not interested in running a studio with a revolving-door-type schedule where clients show up for hurried back-to-back appointments. I like to let each session develop in a more unstructured, creative way. I give each of my clients my best and am well rewarded by high-quality, personal images and good sales. I get to know my clients and become their photographer for life. I wouldn't have it any other way.

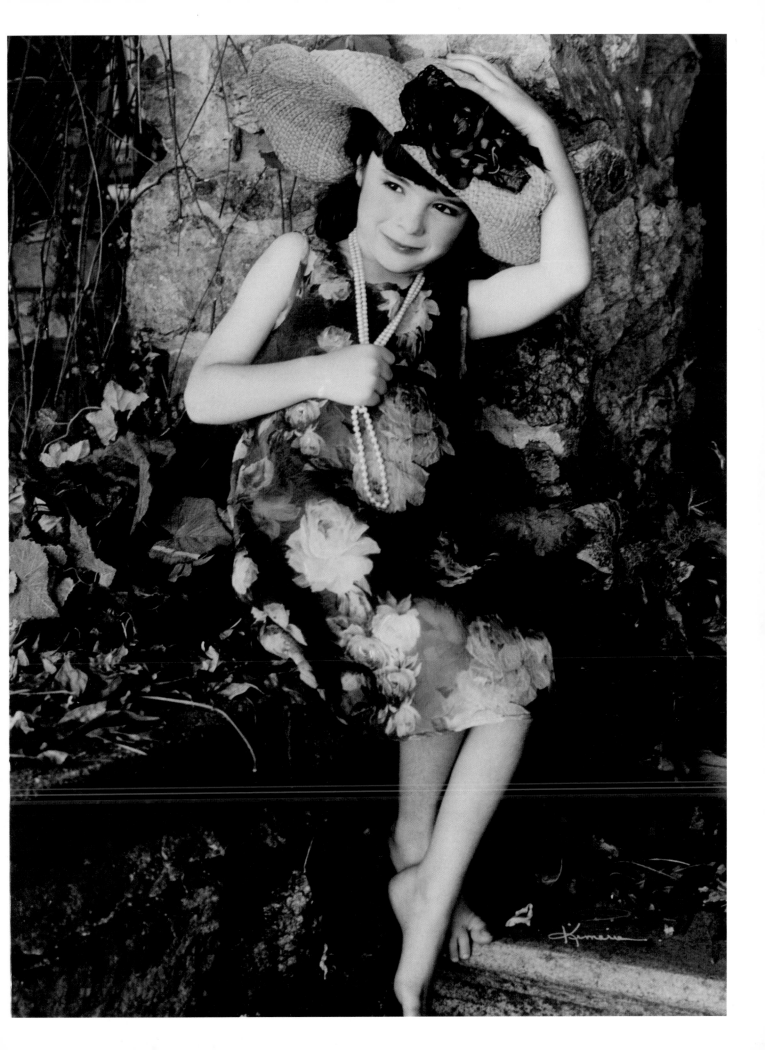

tricks of the trade

As mentioned before, shooting interactive portraits of the smallest of clients makes good sense on many levels. The children are actively engaged, the fear factor is diminished, and their playtime yields more time for you to work your magic!

While I sometimes use squeaky toys to capture a small child's attention (which many photographers rely on to get a full-face image with an ear-to-ear grin), I don't feel pressured to make that kind of image. I've found, instead, that little objects of interest that can be easily made invisible to the camera—or those that work well in the scene—can be immeasurably helpful in keeping these clients cooperative.

At times, I give a child a small, dark-colored rubber ball that can be discretely cupped in the palm of the hand. Also, because I often use flowers in my portraits, I spray them with a rose-scented oil before the session in order to keep a client's curiosity brimming. In this case, however, I placed raisins in the folds of the client's dress and in the area immediately surrounding her. (I'd tried those goldfish-shaped crackers that kids love, but that option resulted in far too many crumbs!) Before creating your own trail of treats, be sure to check with the parents to ensure that the child does not suffer from food allergies.

hats

Hats not only add a great deal of polish to an outfit, but they also serve a problem-solving function. Since most toddlers have fine, sparse hair (and little patience for a hairdresser), a hat is a perfect alternative to an expertly-styled hairdo.

As I always shoot on the child's level, shadows from the brim are never a problem in my images!

finishing touches

Sepia toning and a touch of soft, hand-painted color on the client's lovely apple-round cheek, hat, dress, and hatbox provided an instant heirloom quality that my customer simply adored.

quick reference

CAMERA
Mamiya 645 AFD

LENS
80mm

FILM
Kodak T400CN

APERTURE
f5.6

SHUTTER SPEED
$\frac{1}{60}$ second

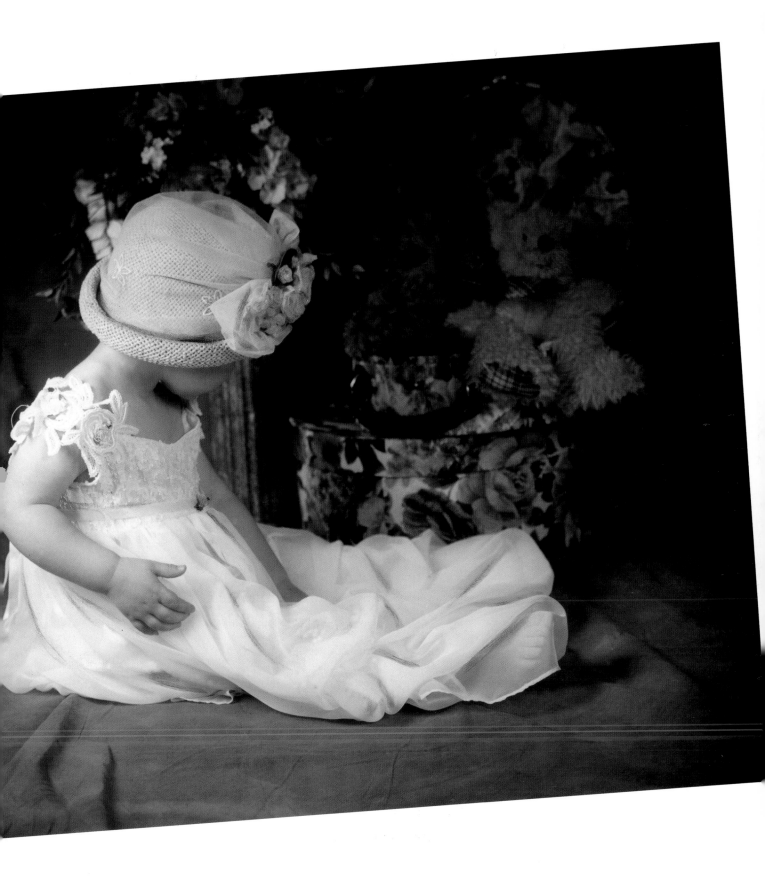

concept

This is my version of a Christmas portrait. The contrived holiday photos of Santa Claus with a small child propped on his knee that are ever popular at the mall, as well as the studio portraits that feature St. Nick sneaking across a painted backdrop, just don't appeal to me. Too often, parents pay good money for traditional holiday photos and are later torn between displaying them permanently in their homes or unpacking them, dusting them off, and hanging them on the wall for only a month or so each year. To me, a winter-scene image like this one is more versatile and subdued; additionally, the concept lends itself equally well to non-Christian holidays.

clothing and props

While I typically instruct my clients to avoid wearing white, pale pink, or baby blue tops for outdoor sessions, in this "outdoor" image, this young lady's creamy-white clothing was undeniably right-on. She seems in her element in this scene—and much like a snow angel. The fiberfill "snowdrifts" that lie all around and the lone pine on the left add a traditional holiday flair.

In this portrait, the same type of garland that is featured in other garden-style images now serves as an old-fashioned, whimsical string of flowers lovingly draped, extending a warm welcome to visitors.

finishing touches

This photograph was taken with color film. I used oils to emphasize the movement and beautiful tones in this client's hair and applied color in other

This is my version of a Christmas portrait.

select areas of the image as dictated by the highlights and shadows inherent in the print.

quick reference

CAMERA
Mamiya 645 AFD

LENS
80mm

FILM
Kodak Portra 160NC

APERTURE
f5.6

SHUTTER SPEED
$\frac{1}{60}$ second

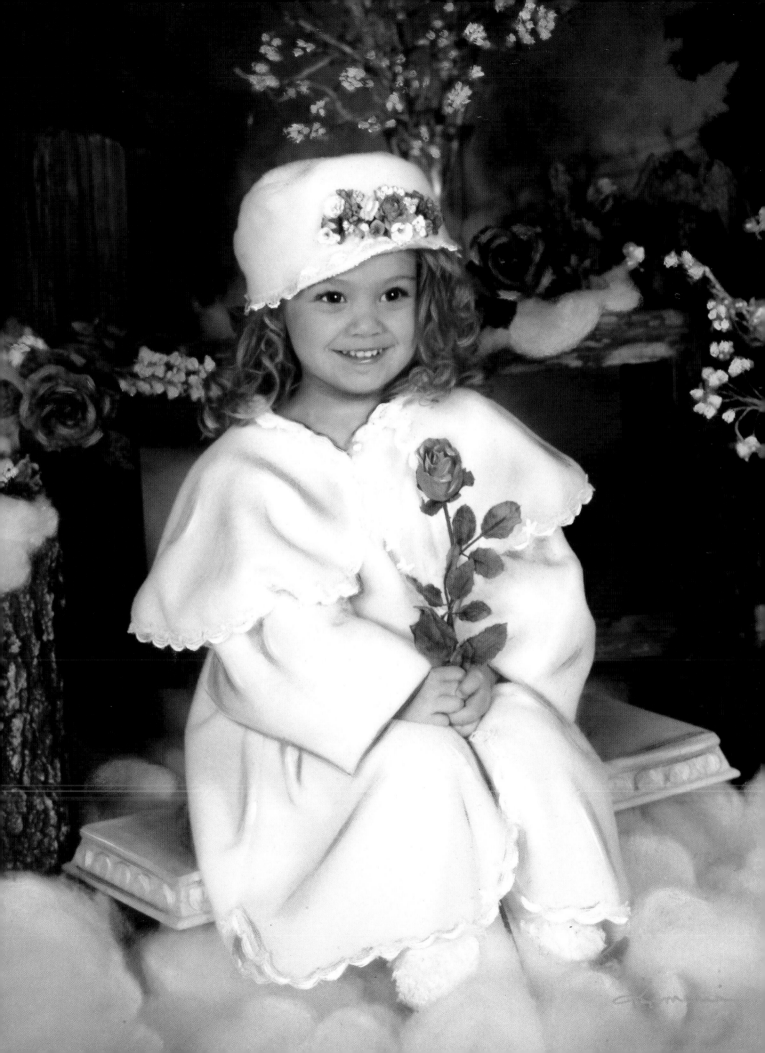

angel babies

This is the very first Angel Babies portrait I ever created. I've always loved angels and was excited to bring this concept to life. The little girl participated in a photo session with her siblings earlier on, and I knew that she'd be a great candidate for this portrait concept.

I shot this portrait in black & white, and when I viewed the print, I felt it would benefit from some added color. With a 3½x5-inch print and a Mar-shall Oils kit, I tried my luck at hand-painting. I was amazed at the results!

Since creating this image, I've made several variations on the theme, some of which are shown on the following pages.

quick reference

CAMERA
Mamiya 645 AFD

LENS
80mm

FILM
Kodak T400CN

APERTURE
f8

SHUTTER SPEED
1/60 second

apart, the painting is actually incredibly time-consuming, and, as a result, my hand-painted portraits run from $450 to $750 per print.

All of my Angel Babies portraits are done in black &

This is the first Angel Babies portrait I ever created.

They are a very popular but high-end product that is just not appropriate for every client.

Each of my signature Angel Babies portraits involve four major components: black & white film, angel wings (these are large but lightweight and somewhat awkward; they attach via twine "straps" that encircle the client's shoulders); and a white tulle "dress," which is sometimes recolored in the "mandatory" hand-painting process. While the artwork truly sets these images

white, as it yields ghostly white skin tones that I find appealing. I don't think the resultant ethereal effect would come through with color film.

To create this image, I deviated from my favored aperture–shutter speed combination of f5.6 at 1/60 in order to downplay some of the fabric folds in the background.

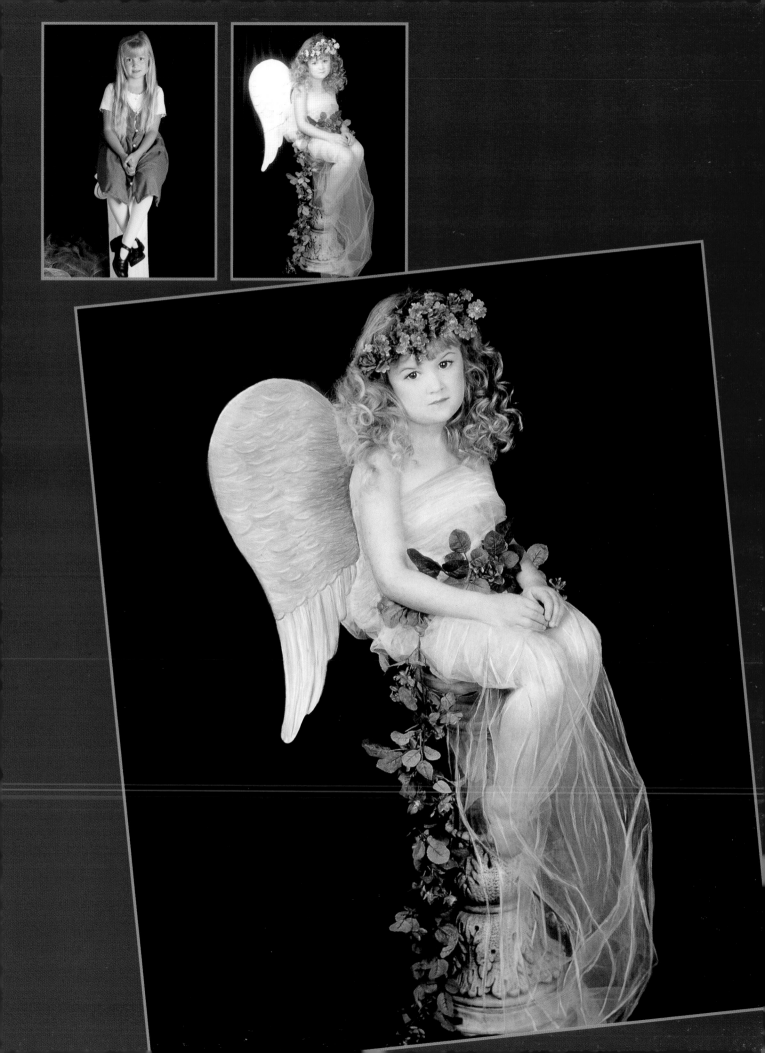

winging it

I'm a very intuitive person, and intuition is the cornerstone of my art. I don't adhere to strict posing and lighting standards; in fact, I often make up the rules as I go along. My thinking is that it is not technique that sets a photographer apart in this business. It's the photographer's vision that either draws clients in or turns them away.

In truth, this portrait was the result of an experiment: I had a single exposure remaining on

quick reference

CAMERA
Mamiya 645 AFD

LENS
80mm

FILM
Kodak Portra 160NC

APERTURE
f5.6

SHUTTER SPEED
1/60 second

the roll of film and decided to depart from the approach I used for the rest of the session.

I'm a very intuitive person; it is the cornerstone of my art.

I turned off all of my lights, leaving only the light of the candle to illuminate my lovely subject, and hoped for the best.

When I received the proofs from my proofing lab, I found that the image was quite underexposed and, as such, that the lab technician hadn't even bothered to print the portrait. I pulled out the negative, threw it onto my light table to get a good look at the results, and saw a ghost-like image there. I sent the image to Snelson's lab and asked them to convert the image to black & white and do what they could to pull out the exposure. They were able to print the portrait successfully, and to my surprise, the candle wasn't over-

exposed. With the addition of some judicious hand-painting to add the "vanilla" to the candle and a soft red to the flowers, I was able to further define the subject and truly bring this well-received image to life.

the payoff

For me, going out on a limb creatively earned high honors. In 1999, I was the recipient of a Grand Award in the Premier category at the annual convention of the Wedding and Portrait Photographers International (WPPI) in Las Vegas, Nevada. The same organization also bestowed me with a First Place Award that same year.

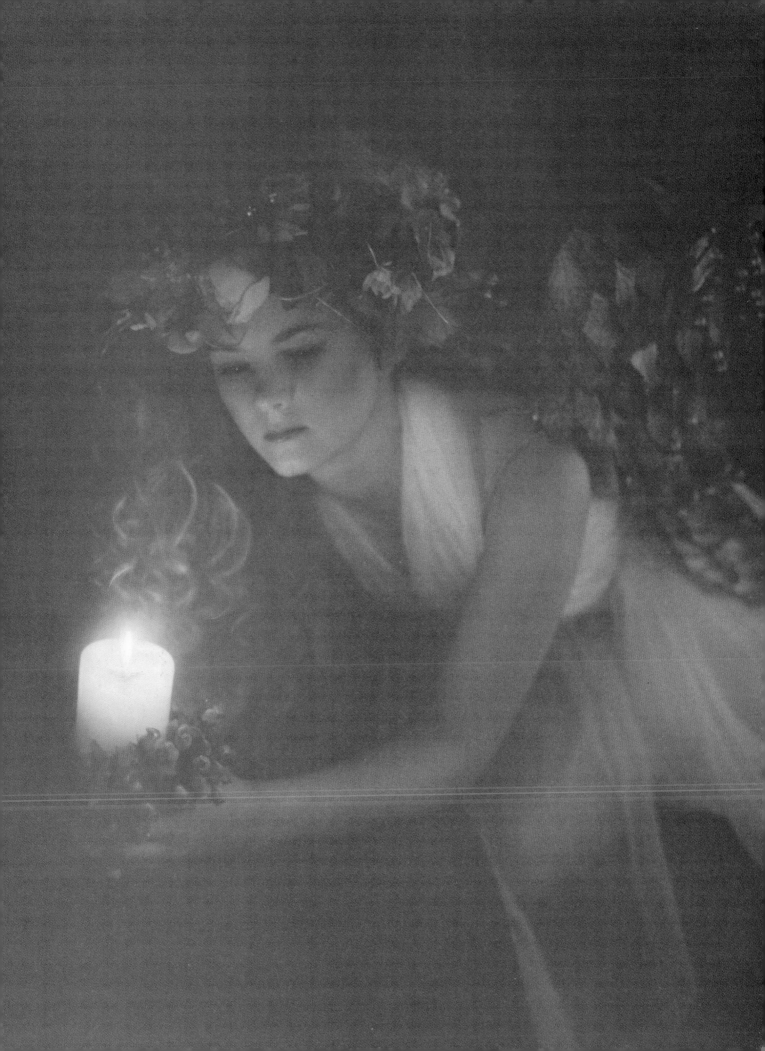

what to paint?

The lips, cheeks, and eyes are prime candidates for hand-coloring not only in my Angel Babies portrait line but in all of my painted images. I generally add color to other elements in the scene as well—to flowers, to the hair, and to the tulle, for example. Again, while shooting in black & white allows me to achieve the smooth, near-white skin tones that the Angel Babies images command, without the hand-coloring, the result is less than heavenly.

quick reference

CAMERA
Mamiya 645 AFD

LENS
80mm

FILM
Kodak T400CN

APERTURE
f5.6

SHUTTER SPEED
$\frac{1}{60}$ second

Additionally, hand-painting a portrait allows for a certain amount of creative license. In

I use a wide variety of brushes to get just the right effect.

some of these images, I've added some brush strokes to play up the flow of the tulle—a detail that is sometimes obscured in these images. Most clients also benefit from some added highlight to their hair; again, this helps to add definition and plays up the contrast in the final image.

highlights & shadows

The beautiful thing about adding oils on a black & white print is that you essentially begin with a blank slate. On the other hand, you also have the benefit of using to your advantage the obvious shadows and highlights that a grayscale image provides. Needless to say, that one advantage makes your work as an artist much easier.

I have no artistic training, but have had much success with my hand-painted images. I use a wide variety of brushes to get just the right effect and to capture detail, and I simply use a cotton ball to "erase" any mistakes as I go. The oils are slow to dry; consequently, I have a lot of leeway in getting every detail just right.

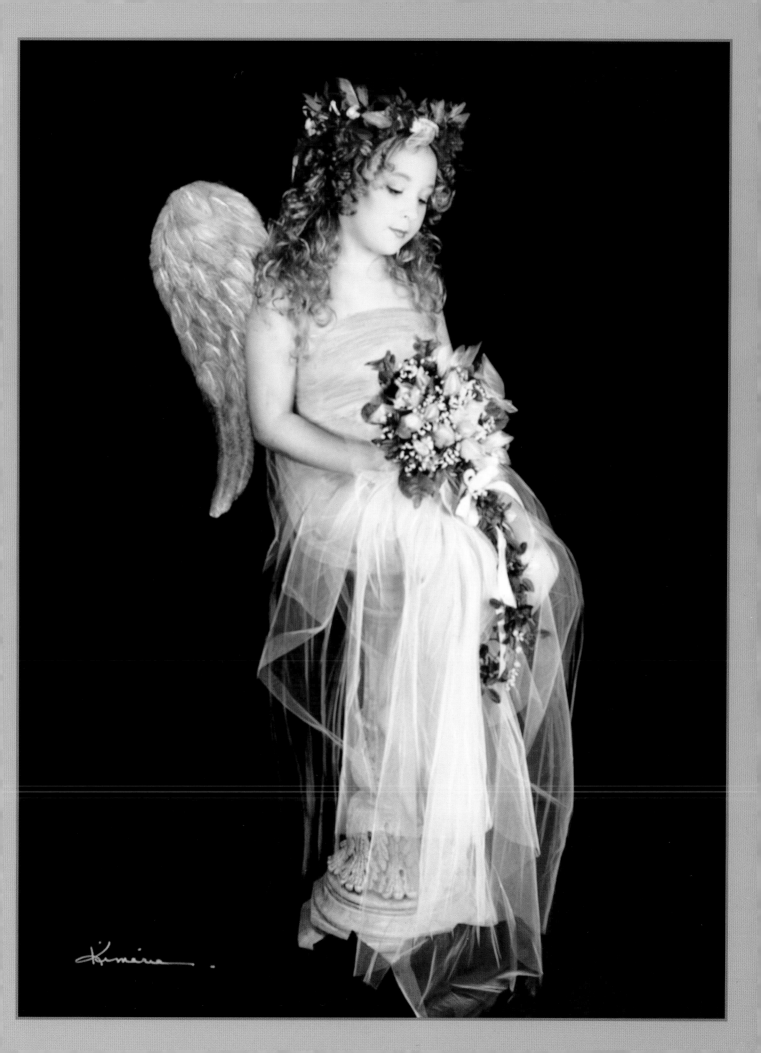

composition

This horizontal composition was initially a vertical image. However, the too-busy background dictated that I crop out some of the scene to simplify the image and draw the viewer to the client's beautiful face. The result is a much more serene feeling in the image, which certainly supports the subject's pose!

the wings

In this image, as in other featured Angel Babies portraits, I hand-painted the feathers in

quick reference

CAMERA
Mamiya 645 AFD

LENS
80mm

FILM
Kodak T400CN

APERTURE
f5.6

SHUTTER SPEED
1/60 second

the wings. I have two styles of wings; one is gold and doesn't have the soft, romantic feel I

I used bolts of black fabric to create the backdrop.

gravitate toward for these portraits. The other pair is white and feathered, but I've had much better results with the gold wings and hand-painted feathers.

Painting in the feathers is the most challenging and by far the most time-consuming part of the image-making process. It requires a steady hand and a great deal of patience! However, the results are undeniably worth the time and effort.

fabric finds

While I often use painted backdrops, I have also been known to purchase bolts of fabric at my local craft store. I drape it over a dowel rod that's suspended from the ceiling and arrange it so that it is pleasing to the eye. It's a great way to introduce a lot of variety— especially if you have a small budget.

In this case, I used bolts of black fabric to create the backdrop and to cover the pedestal upon which the client is leaning. The pure black backdrop beautifully frames this serene, porcelain-skinned client and ensures that the viewer's eye is riveted to the subject.

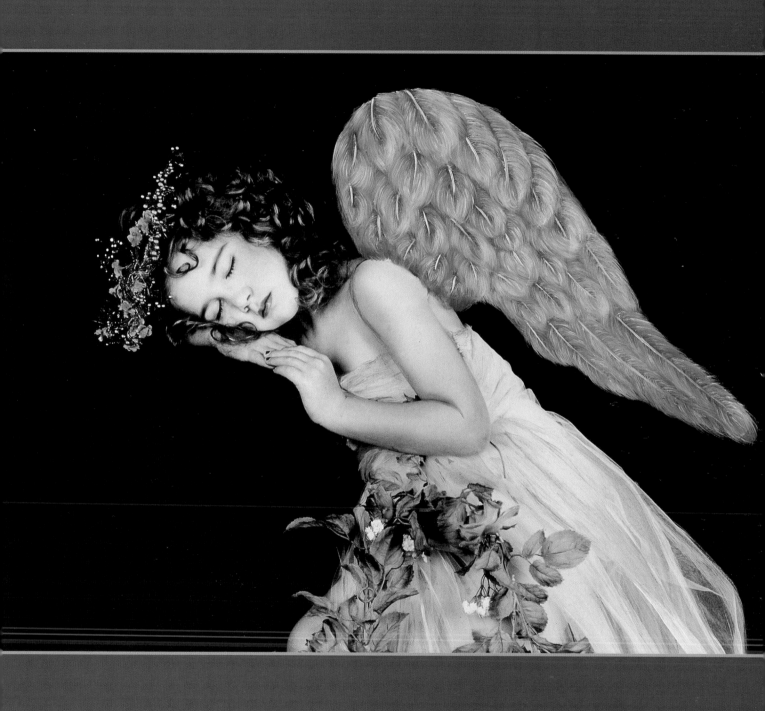

While I typically paint in the downy white feathers in my Angel Babies portraits, the wings that the clients wear for the session are actually made of a gold, plastic material. This little girl's portrait had a certain edge to it, and I felt that the bolder coloration of the wings, which I usually try to conceal, supported the mood better than the softer, wispy painted wings would. Again, this is a black & white portrait: I added some yellow paint to the wings to reintroduce the metallic tone in the print.

quick reference

CAMERA

Mamiya 645 AFD

LENS

80mm

FILM

Kodak T400CN

APERTURE

f5.6

SHUTTER SPEED

1/60 second

suitability

I tell prospective clients that my Angel Babies portraits are

This little girl's portrait had a certain edge to it. . . .

appropriate for children aged three and up—but the child must be what I call a "good" three. In other words, since these sessions involve costuming, hairstyling, and even makeup application, young clients need a great deal of patience. They must also be able to follow directions.

Waiting isn't the only challenge that faces these clients, however. While I have two sets of wings at my studio—one for children and the other for adults—children under three will not fare well under the weight (which is actually very minimal for the recommended age group) and size of the wings.

a holiday touch

This image was taken before Christmas, and I pulled the garland and violin out of my seasonal window display. The end result is a glamorous image with an earthy, rustic feel.

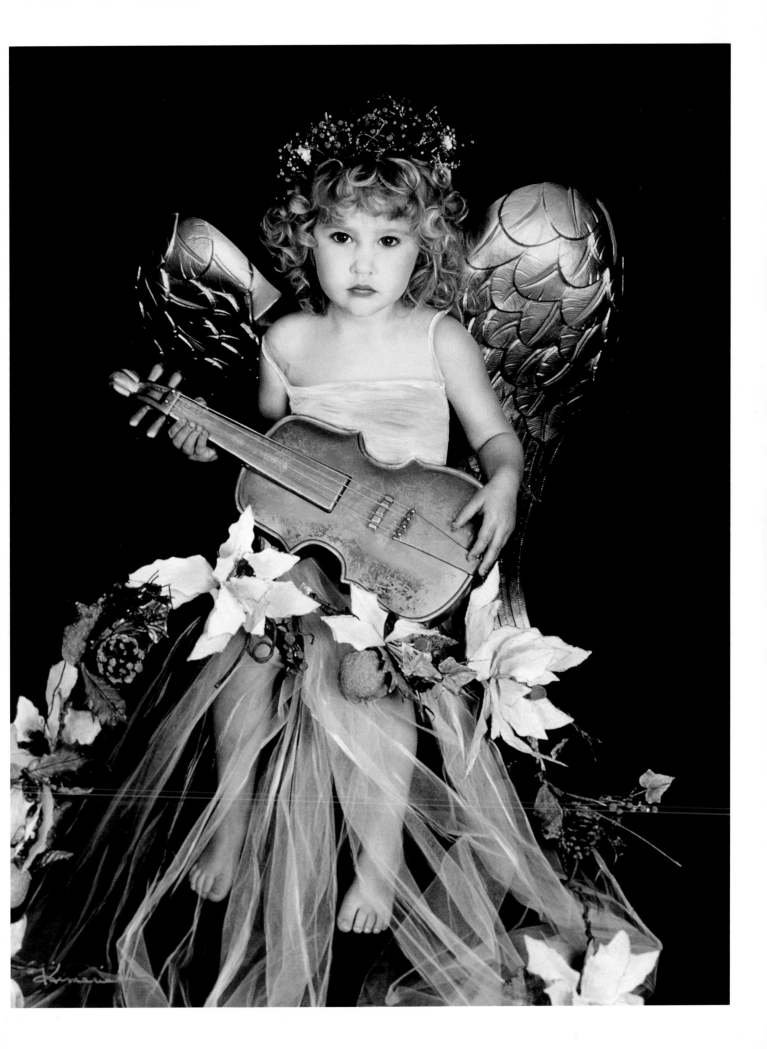

This is another image taken during the Christmas season. Like the portrait on page 52, this image is festive but not overbearing; the gilded leaves and berries in the garland and headpiece hint at the holiday without any blatant Christmas props that make it difficult to display the image year-round.

Needless to say, these images have a decidedly feminine appeal. I've not yet developed a spin-off on this portrait style that's suitable for boys—but I have had requests!

quick reference

CAMERA
Mamiya 645 AFD

LENS
80mm

FILM
Kodak T400CN

APERTURE
f5.6

SHUTTER SPEED
$\frac{1}{60}$ second

preparations

During the consultation, I inform my clients that they should come to the session with clean, dry hair and skin. With a background in makeup artistry, "making over" my clients is important to me. I curl each of my clients' hair using either hot rollers or "hot sticks"; these thin, bendable rollers will produce voluptuous and springy curls in even the straightest, most stubborn hair. While the makeup I apply for the children's black & white portraits isn't intended to show, it really makes my clients feel special and keeps them occupied as their curls are setting. Providing this personal attention to my clients also helps them to shake off their pre-session jitters, resulting in a more profitable portrait experience for the client and myself alike.

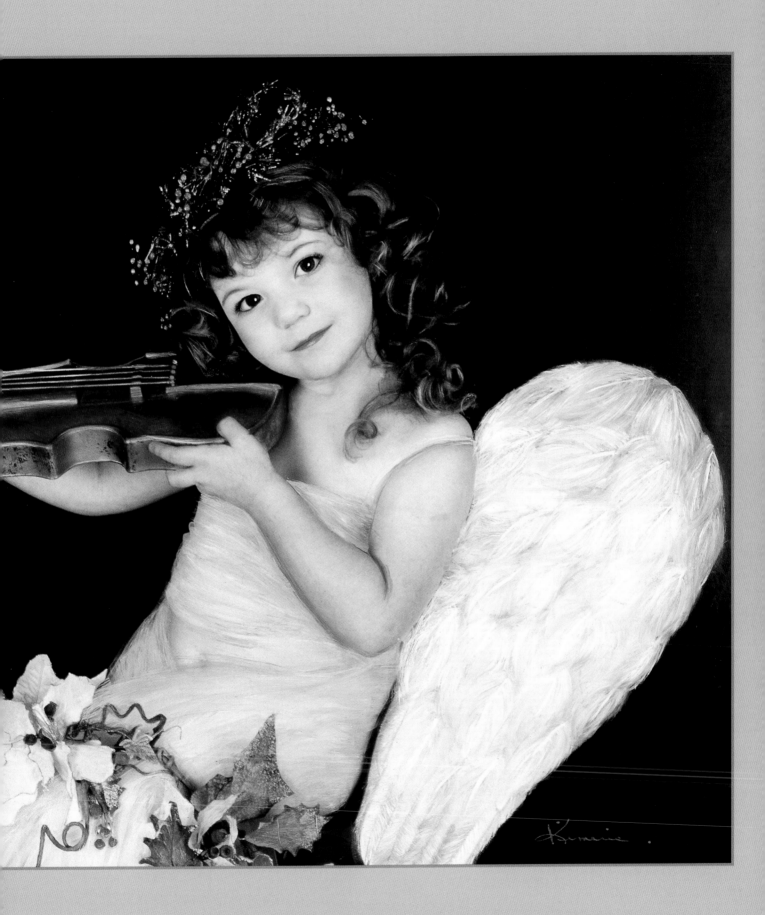

It hardly seems like this image was created on film. Every inch looks hand-painted! Truth be told, this portrait is the result of a happy accident; one of my lights didn't fire, and the portrait, consequently, was underexposed. The resulting image was muddy, but with some doctoring with oils, it really came to life. In its final form, the subject seems awash in moonlight.

preparations

I generally shoot about thirty exposures for each client when I'm working with toddlers. For older children and adults, fifteen exposures is generally suf-

This image is the result of a happy accident.

ficient. I don't take the picture if what I see through my viewfinder doesn't please me. While I pay special attention to posing my clients, and refine each client's positioning to ensure that they look their best, the older child's and adult's time in front of the camera generally amounts to only about ten minutes, whereas a younger client may require an hour and a half. The preparation for the camera—from hairstyling and makeup application to costuming—far outstrips this, lasting roughly forty-five minutes per client.

turnaround time

The turnaround time for each of my Angel Babies portraits is approximately two to three months—but they are worth the wait! Again, the hand-painting process is surprisingly labor-intensive. To protect the artwork and ensure the best possible archivability, I coat each hand-painted portrait with three coats of matte acrylic sealant. While the sealant plays a role in protecting the image, it is important to instruct customers to place the portrait behind glass, as they would with an unpainted photograph; this simple precaution will ensure an improved longevity for the print.

Each finished painted portrait print is a hand-crafted, one-of-a-kind piece of art. Accordingly, I sign my name to each portrait before it is delivered to the client.

quick reference

CAMERA
Mamiya 645 AFD

LENS
80mm

FILM
Kodak T400CN

APERTURE
f5.6

SHUTTER SPEED
$\frac{1}{60}$ second

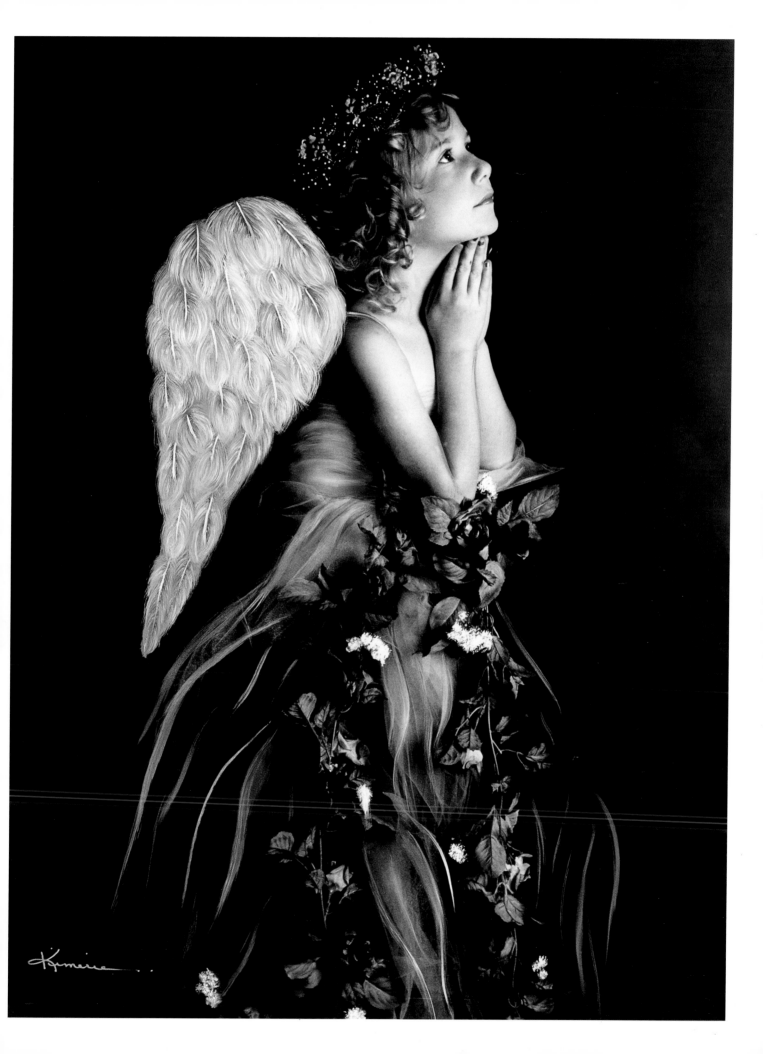

props

When you use imaginative props, you're sure to create images that stand above those of your competition and, in turn, will earn increased client loyalty.

The pink "umbrella" was fashioned from cardboard by my fiance and hung from the ceiling with fishing line; and the chandelier baubles suspended from the ceiling in the same manner made for great raindrops. Fiberfill was used to simulate billowy clouds.

quick reference

CAMERA

Mamiya 645 AFD

LENS

80mm

FILM

Kodak Portra 160NC

APERTURE

f8

SHUTTER SPEED

1/125 second

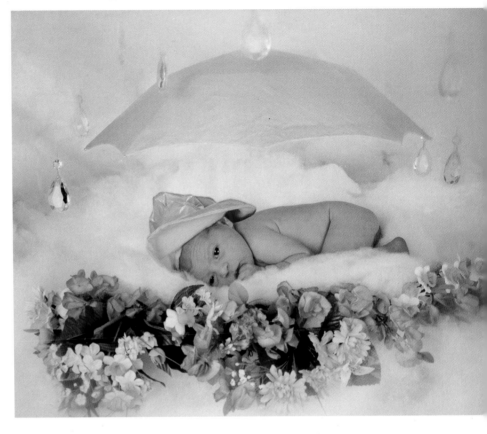

a supporting role

The cherubic baby pictured on the facing page looks like she is having the time of her life amidst these fanciful props! She was positioned inside of a goblet-shaped planter, which was placed on top of a waist-high table. To ensure that baby wouldn't go anywhere, her mom literally played a supportive role—she held on to her from behind the setup.

In the above image, the same concept was employed; however, the planter used opposite was eliminated and the spring flowers were moved out of reach, making this a more suitable, newborn-friendly portrait scenario.

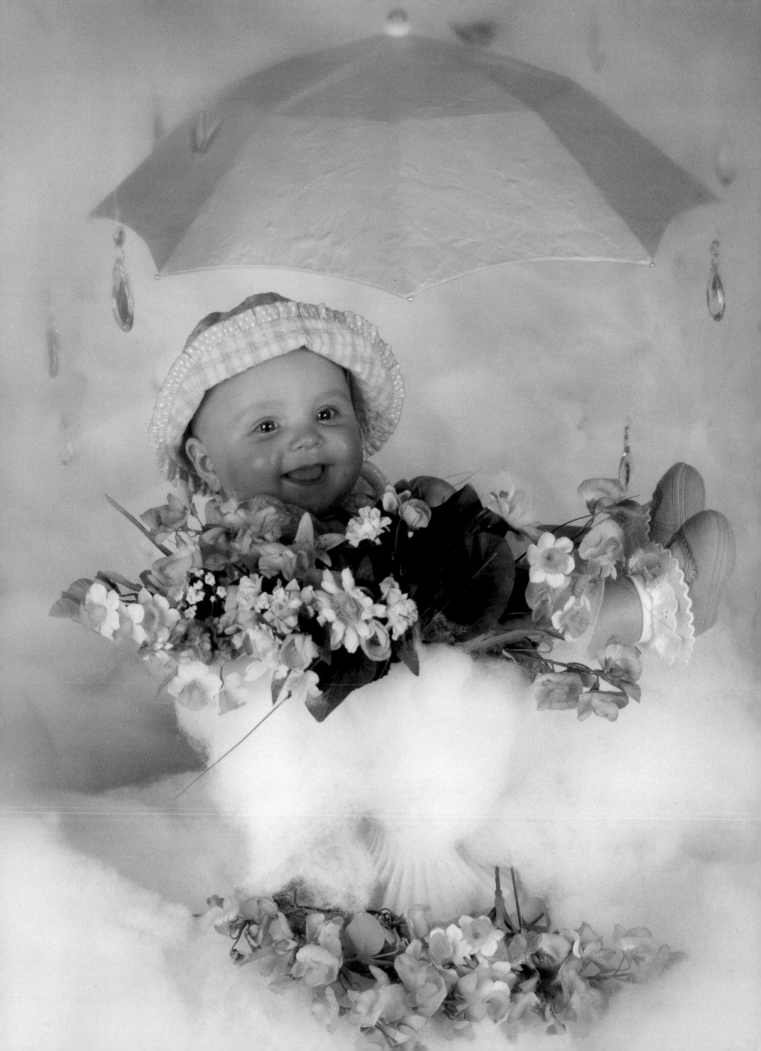

newborns

When it comes to photographing infants, I pull out all of the stops and cater to their every need. When the baby gets sleepy, I turn down the lights in my studio, turn off the ringer, and even go so far as to lock my doors. With any chance of disruption minimized, I then pick up the camera.

lighting

Here, Mom fed the baby, and after some time, was able to lay the sleeping infant down. When we were sure she was sleeping soundly, I lit each of the candles—the sole light source in this image. As unwanted movement wasn't a

The candlelight and gilded fruits in the image seem very magical.

concern in this case, I was able to rely on a slow shutter speed, which captured the candle light for a nice effect.

The candlelight, gilded fruits, and natural textures in the image seem very magical. The black backdrop and lighting pattern serve to frame the subject, who is innocently unaware of the photo fantasy that has unfolded around her.

fit for a queen

As you've likely noticed, I often adorn my female clients with floral headpieces; I feel that they add a nice touch to the images, and incorporate added color and texture in the scene.

I create custom garlands, floral arrangements, and headpieces to coordinate with various backgrounds and portrait concepts. I pick up all of the necessary elements at my local craft store and weave them together while watching TV.

Quick reference

CAMERA
Mamiya 645 AFD

LENS
80mm

FILM
Kodak Portra 160NC

APERTURE
f8

SHUTTER SPEED
$^1/_{15}$ second

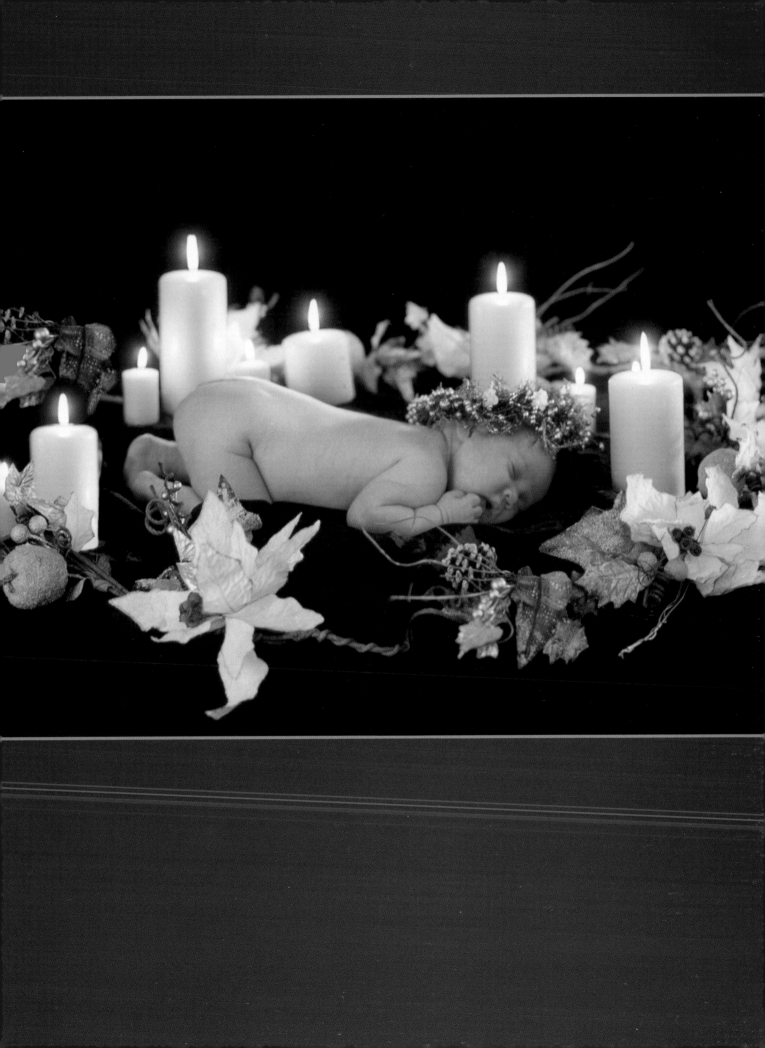

it's all in the timing

Casey was seven months old when I created this image; in fact, the seven roses that encircle her were selected to pay homage to her age.

Casey was a very active baby who was all over the place! It was impossible to keep her still and, consequently, getting a useable portrait posed a serious challenge.

When my fiance walked in the door, Casey stopped in her tracks to gaze up at this tall, handsome man. I finally had a lucky break! Since I was ready, I was able to get the image.

At a later session, when Casey was two, I wasn't able to get

Casey was a very active baby who was all over the place!

an image I liked; she was far too active. Photographers and clients alike need to realize that there are times when an artistically profitable session simply will not happen. You've got to respect a child's mood and schedule. If they're hungry, it's just time to eat. It's better, after all, to get images that please your client than to shoot through the session, get marginal images, and risk losing your client.

timeless portraits

A string of beads is a favorite plaything for many babies, who thoroughly enjoy exploring new textures and sounds. The beads

fit in with my philosophy on props, too. In short, I prefer to use simple props for my children's portraits, such as old-fashioned wooden toys and antique-style teddy bears that appear well-loved. I won't photograph kids with trendy cartoon characters on their clothing or with modern toys in the image. Keeping the image simple and timeless ensures that it can be enjoyed by a larger audience, for a longer period of time.

quick reference

CAMERA
Mamiya 645 AFD

LENS
80mm

FILM
Kodak T400CN

APERTURE
f5.6

SHUTTER SPEED
$1/125$ second

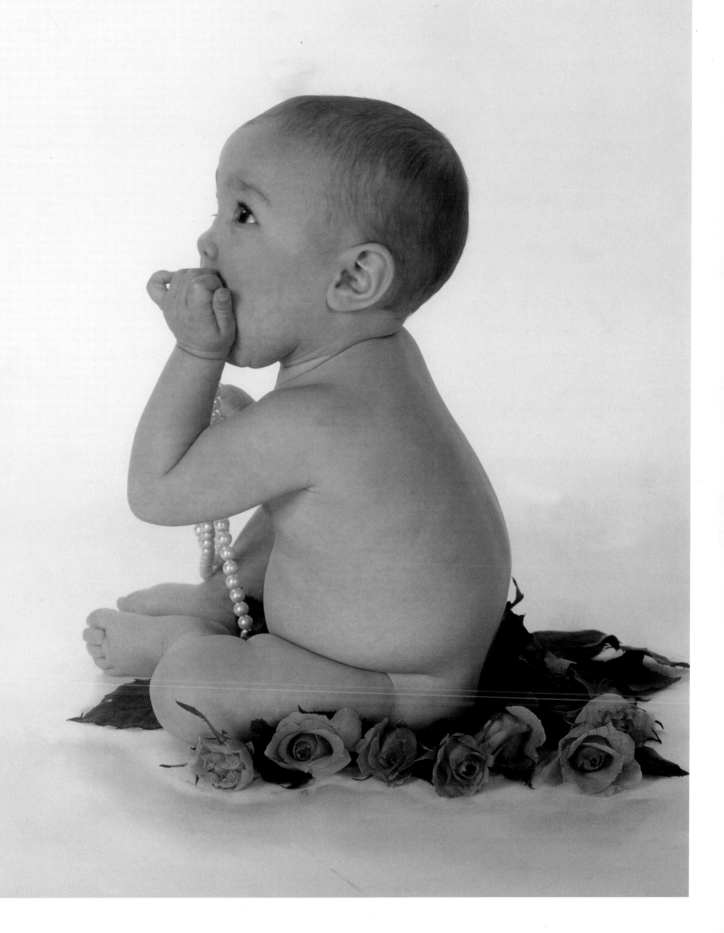

lasting impact

This image really packs a lot of punch. While the mother chose not to be fully pictured in the image, I encouraged her to take part in the image. I have found that photographing a baby against a wide, near-featureless backdrop cannot properly document the infant's size—something that should be well documented as it will change all too soon.

I like to incorporate an adult in the image—to some capacity. Here, the mom and baby are dressed in complementary outfits, and the former is lovingly cradling her precious child.

The question of what to paint is easily answered.

Taken together, the pose and clothing lend a timeless quality to the grayscale image. It could have been taken two years ago, or a hundred years ago.

artistry

If you haven't done very much hand-painting, you don't know what you're missing—and you've been depriving your clients of some strikingly beautiful, hand-crafted work (not to mention throwing away a great source of profit!).

Sure, hand-coloring images can be intimidating, but it's not as hard as you might think. The question of what to paint is easily answered: paint the most important elements in the scene, mixing colors to get the desired hue. When applying the oils, just let the highlights and shadows in the scene dictate your color choices and density of the application. And don't fret about making mistakes—the effects of a jittery hand are easily reversible; all it takes is a cotton ball, and you've got a clean slate!

It's hard to imagine the image on the facing page printed in color. If you picture the scene rendered in black & white—without hand-coloring, you will see how a light, selective application of paint can completely transform your portraits. The effect is a very selective coloration that appears incredibly natural-looking in the final image. Just look at the cheeks of this small subject!

quick reference

CAMERA
Mamiya 645 AFD

LENS
80mm

FILM
Kodak T400CN

APERTURE
f5.6

SHUTTER SPEED
1/60 second

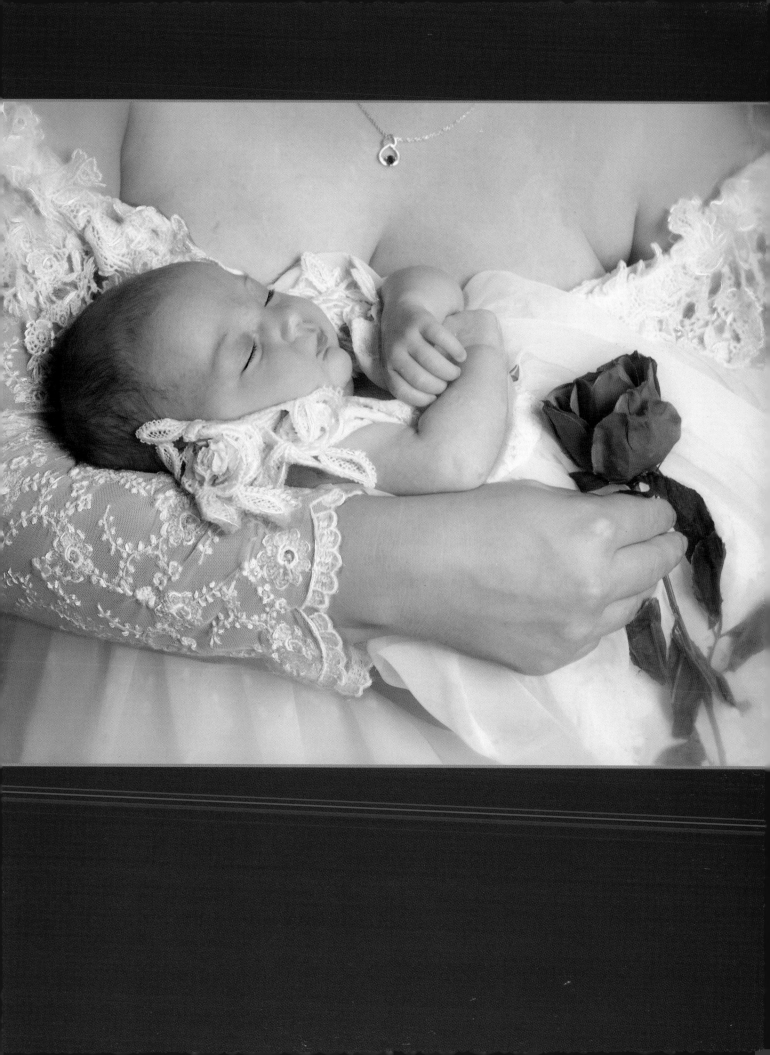

time capsules

There are so many times when I wish I were a fly on the wall. My work is under many Christmas trees on December 25th. My goal in life is to create forever portraits—something that is going to be on people's walls for one hundred years. Each image is really special to me, and I know my clients feel the same way, too.

When I frame a portrait, I put a "time capsule" inside—a little note—and then I seal it all up. Who knows how long it is going to take for that photograph to be popped out of that frame—but when it is, someone will find a note in an envelope from me. To date, there is only one woman who knows that I did this for her daugh-

When I frame a portrait, I put a little "time capsule" inside.

ter's portrait. She said, "You know, Kim, it's killing me not to peel back the paper behind that frame."

These are my kids out there, and this simple gesture helps me to build a legacy.

image specifics

This image shares some similarities with the one on the previous page; both feature the same type of grouping, both are black & white prints with a touch of added color and in both, Mom is somewhat obscured, leaving the viewer to note the bond between the sub-jects, but, nevertheless, to focus most of their attention on the new baby.

This warm-tone black & white image also has a timeless appeal. I like the cropping of the image a lot—this isn't how I framed the image in my viewfinder, but in shooting with my 80mm lens, I achieved an image that would allow for some trimming in the height.

To finish the portrait, I added color to both clients' lips, applied color to the wedding ring, and painted in added detail in the lace.

quick reference

CAMERA
Mamiya 645 AFD

LENS
80mm

FILM
Kodak T400CN

APERTURE
f8

SHUTTER SPEED
1/60 second

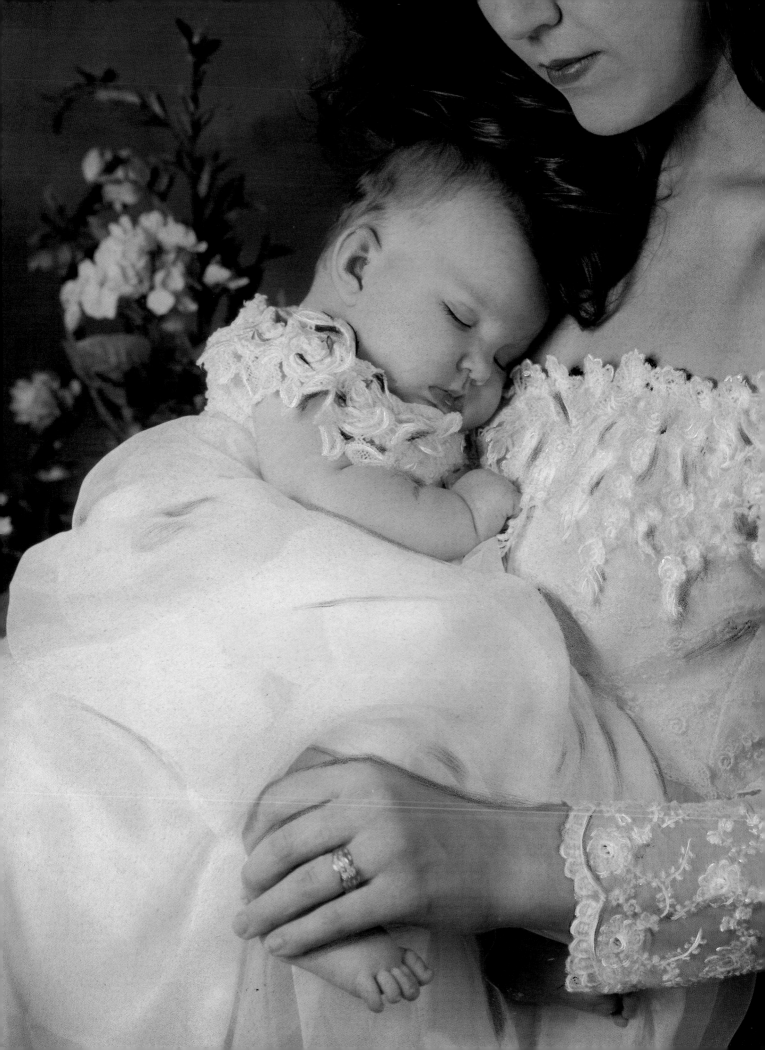

This one was made when I first started to hand-color black & white portraits. I added a lot of detail to this image.

props

I purchased this buggy from a local gift shop. It was initially quite expensive, but when the store was going out of business, I got it at a great price! The flowers came from my local craft store.

marshall oils

I not only use oils to bring out the important elements in a

quick reference

CAMERA
Mamiya 645 AFD

LENS
80mm

FILM
Kodak T400CN

APERTURE
f8

SHUTTER SPEED
$\frac{1}{60}$ second

scene—I also occasionally use them to creatively alter the color or texture of various

I changed the color of the dress from pink to blue. . . .

image elements. For instance, if I envision that the black & white portrait would have more punch if I painted the client's dress blue, rather than coloring it as it actually appeared, I can easily make that alteration. Applied thinly, these paints are translucent and make the added detail seem natural. In this case, I changed the color of the subject's dress from pink to blue and painted her pretty fabric hat blue to match.

If you are an experienced fine artist or have the confidence you need to really push the boundaries of your work, you can also add other elements to an image—just as a painter would to a blank canvas.

fringe benefits

At the time this image was taken, my hand-painted portraits were really beginning to take off. This client purchased a 16x20-inch portrait and a series of three 5x7-inch prints in a frame. (At the time, I was willing to paint a 5x7-inch print!)

My customer was from a prominent family with a number of impressive social connections. I gave the hand-painted prints away very inexpensively just to get the word out. Doing work for clients with the contacts you need will really drive your business. With the clients that you draw, you won't miss the money you "undercharged" your initial client. You can't underestimate the power of word-of-mouth advertising!

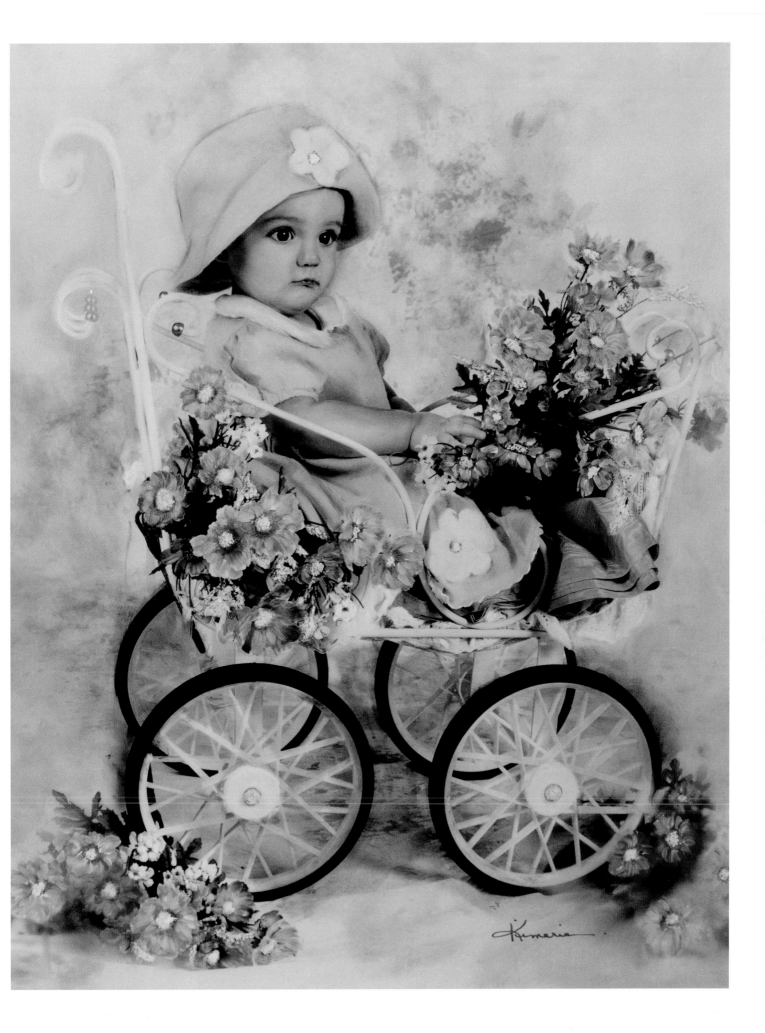

the perfect hat

When I took this portrait, I got the perfect pose and expression and was satisfied with the resulting proofs. On the whole, the mom loved the print, too—but she said she wouldn't buy the 24x30-inch print unless her little girl was wearing a hat.

To resolve this little dilemma, I located a photo of a similarly posed girl in a hat, and the lab added the hat in digitally!

Since then, I've catalogued images of clients in hats and headbands—in a wide variety of poses. These come in handy when a parent just has to have an outfit enhanced—after the session. After all, many small children won't tolerate wearing a headband or hat, though the parents clearly prefer it. Since toddlers often have thin hair that doesn't lend itself well to styling, the hat or headband serves a corrective purpose in the image—particularly in fantasy portraiture! An image-editing program like Photoshop allows you to perfect your image via a wide variety of digital enhancements that will make clients happy and drive your profits.

a supporting role

This little velvet armchair was purchased at a WPPI convention. You can pick up some great deals during the final day of such shows, since vendors are looking to minimize the stock they need to ship home.

quick reference

CAMERA
Mamiya 645 AFD

LENS
80mm

FILM
Kodak T400CN

APERTURE
f8

SHUTTER SPEED
$\frac{1}{60}$ second

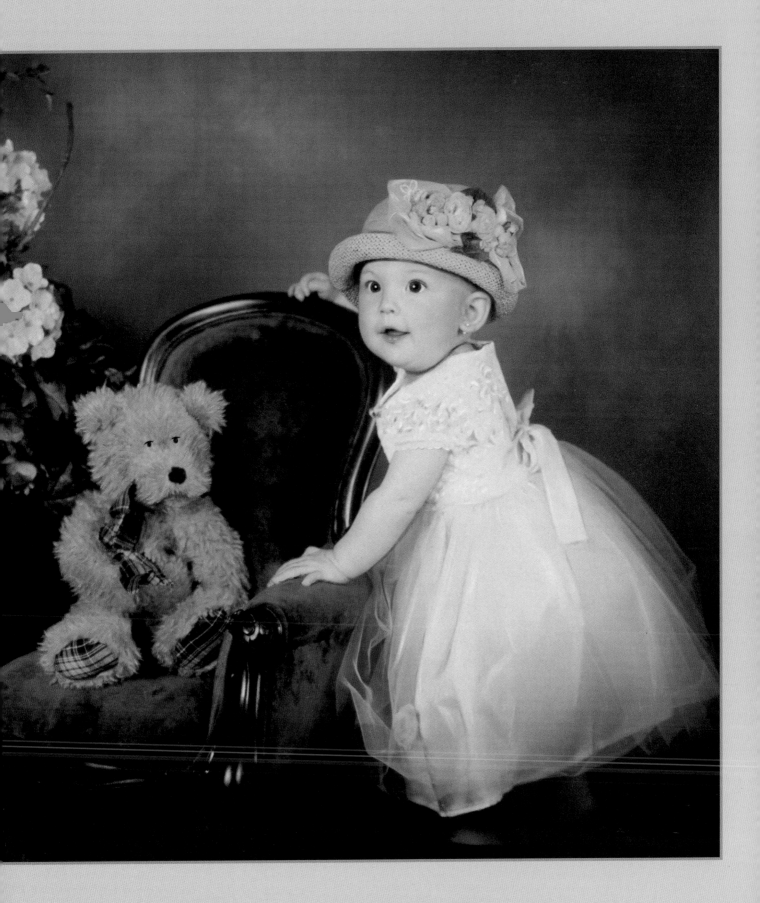

clothing

This client wanted pictures of her newborn baby. The soft, garden-style image I created captured the loving bond between the subjects and has an elegant, timeless quality that is supported by both the painterly backdrop and classic clothing.

Clothing selection is important to every image. It is also a tool that smart photographers use when determining just what type of image and what type of session the client is interested in. For instance, if a woman arrives at my studio wearing a white, gauzy dress, I get the impression that she might like to be photographed in tall grass. If you keep your eyes

Clothing selection is important to every image.

open and listen carefully during the consultation, you'll find that the client sends a lot of clues and, working with these, you can create an image that is perfectly suited to that client.

When photographing two or more clients, it is important that the colors and clothing styles are harmonious. The subjects' clothing doesn't need to match, but coordination is absolutely necessary. Frank Frost, an award-winning photographer, tells clients that, when selecting clothing, they should choose an outfit that incorporates the accent colors used in their home. This is a fabulous idea, since these are

colors that the client likes, and the portrait will be displayed in their home. After all, choosing clothing that works well in a portrait is one thing, but it makes sense to also create a portrait that won't clash with the client's decor.

quick reference

CAMERA

Mamiya 645 AFD

LENS

80mm

FILM

Kodak Portra 160NC

APERTURE

f8

SHUTTER SPEED

$1/60$ second

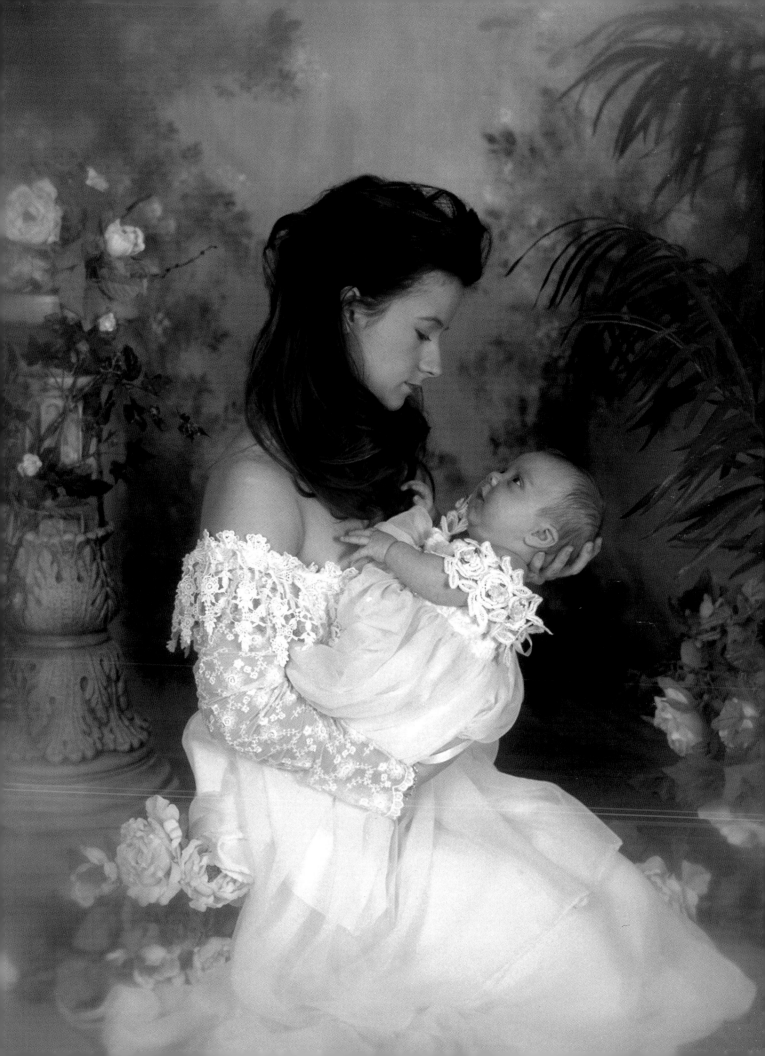

a repeat client

Here are two portraits of a single child, photographed first as an infant, then a bit older, at about thirteen months. While getting a good "pose" and eliciting an expression is always a challenge with infants, there is a philosophy that you must employ to get the image you need: Hurry up and wait. Simply put, this means that, positioned at baby's level, you'll need to keep your eye on the client, with your shutter button finger poised, and wait for the precise moment when opportu-

nity finally knocks. For this age group, this is as close as you can get to guaranteed success in the studio.

In the top image, Sarah was photographed on the floor, atop a tulle-covered pillow, which provided me with the

This is as close as you can get to guaranteed success. . . .

opportunity to achieve good perspective.

The portrait at the bottom of the page was created after I wrapped up a session with Sarah and her brother, Tristan (see pages 22–23). In fact, she's wearing the same dress that's pictured in the earlier images, though it seems to take on a new look in this portrait.

The twenty-five-year-old rocking chair pictured here is built differently than most. It's quite low to the ground, and the seat

is angled toward the back, making this a perfect prop for safely keeping very small children in position.

Sepia tones not only improve upon the antique feel of the lower image, but the warm tones tend to soften the ele-

ments in the scene, and thus help to keep the viewer's focus on the subject. Sepia toning is also quite versatile: depending on the image, I can request that the lab produce a true brown sepia tone, a pinkish-brown, or even a more yellow-brown hue.

quick reference

CAMERA
Mamiya 645 AFD

LENS
80mm

FILM
Kodak T400CN

APERTURE
f8

SHUTTER SPEED
$\frac{1}{60}$ second

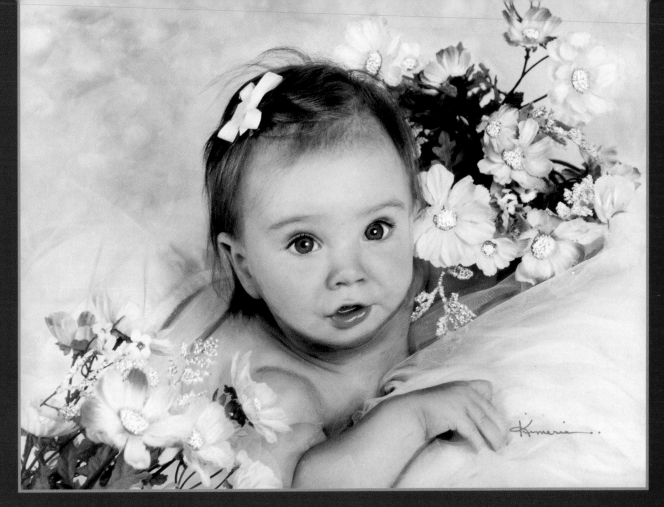

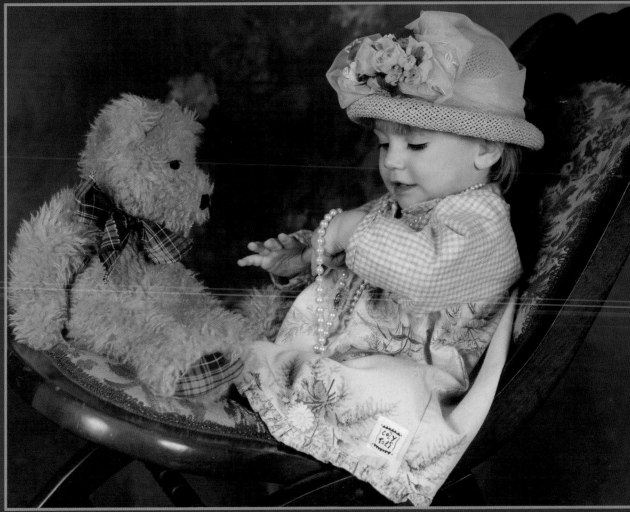

digital technologies

Today's digital technologies allow photographers to make a wide variety of image-saving alterations—from retouching, to correcting color, to creating composites to produce one perfect image.

I realized shortly after beginning this session that a digital composite would be necessary to achieve a good portrait of these three very active young children. (The mom provided a strong hint regarding what I was in for—she told me that if

quick reference

CAMERA

Mamiya 645 AFD

LENS

80mm

FILM

Kodak Portra 160NC

APERTURE

f11

SHUTTER SPEED

$\frac{1}{60}$ second

I produced a great portrait of her kids, she'd kiss my feet!)

To compile the individual elements, I first photographed the

. . . if I produced a great portrait of her kids, she'd kiss my feet!

eldest child, age five. She was very cooperative, and achieving a good image was simple. Next, I positioned the two-year-old child on the bench with her older sister standing behind her. As you can see, her big sister was really hamming it up for the camera—but this was the only workable portrait of the younger girl that I was able to get on film. Finally, I positioned the youngest child on the left of the frame to fill in the composition-in-progress; I had to work quickly before he dropped down to his knees and crawled away! After wrapping up the shoot, I photographed the background—without subjects. I then had four separate

quality frames to send to my lab.

The digital imaging staff at Snelson's did an incredible job piecing the final photograph together. I had them print a 16x20-inch image, and I hand-painted the finished print with Marshall Oils. Needless to say, the mom was impressed. She came to my studio with a large brown bag, pulled out a pair of costume feet and big, comical red (sticker) lips. As promised, she paid tribute with these over-the-top props!

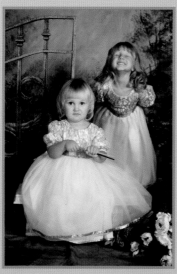
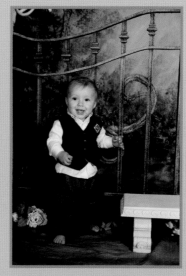

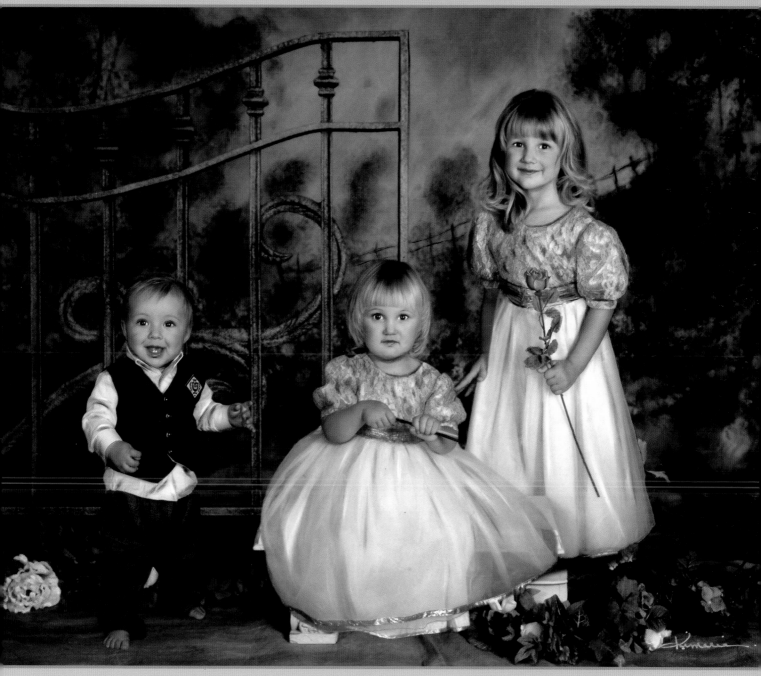

hi mommy!

How do you keep a child's gaze fixed on a certain spot long enough to get the image you're going for? Answer: Have her mom play a game of peek-a-boo.

After shooting several variations of the image seen here, I asked the client's mom to hide behind the window. After she popped up about four times, the toddler got bored. Fortunately, the timing was ripe for creating this enchanting image.

quick reference

CAMERA
Mamiya 645 AFD

LENS
80mm

FILM
Kodak T400CN

APERTURE
f8

SHUTTER SPEED
$\frac{1}{60}$ second

window dressing

Again, if you keep your eyes open, you can find unbeatable, stand-out props that will really expand your repertoire. To cre-

These door frames were mounted on a wooden base for stability.

ate this backdrop, these French door–type plastic frames were mounted on a wooden base for stability. As there is no glass in these frames, there is no potential for injury. There's a secondary benefit, as well: without glass, I can shoot without concern for unwanted reflections.

Sheer white fabric is piled gracefully at the bottom of the frame, adding to the storybook character of the image. I added color in the lace panels, colorized the floral tiebacks, and added the "moonlight-kissed" blue to the tiny dress. A whisper of pink on the girl's right cheek hints at her enthusiasm for this dreamlike scene.

getting to know you

Your studio–lab relationship must be strong in order to get the image quality you are looking for. Get to know all of the major players at your lab. Doing so will heighten their interest in printing your portraits just right.

I use a local lab for all of my proofing needs, and Snelson's Color Lab in Utah processes my enlargements. When working with a lab specifically for proofing, be sure to choose one that will deliver proofs that come close to the quality you require for your final prints. This way, when you send your proofs and negatives to your main lab, they can ensure that the portraits they produce will meet your requirements.

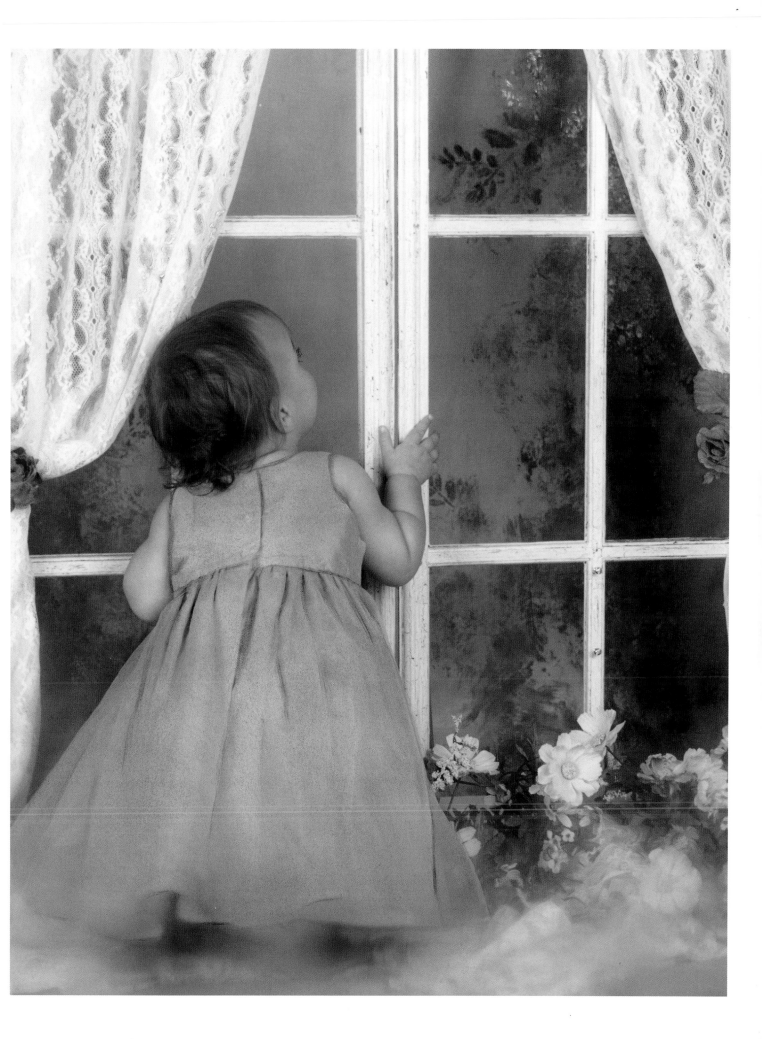

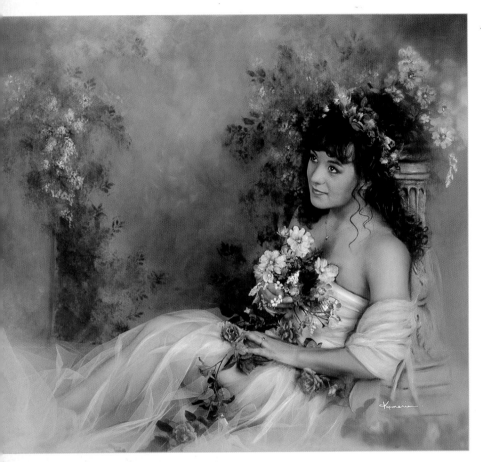

painterly effects

To create the image at left, I used a vignetter to soften the edges of the print. This was my first-ever hand-painted color portrait. I went in with a brush to liven up the colors in the image and brushed the paint on thick so that the brush strokes are visible. I love the result, and have since painted numerous color prints.

cater to the customer

While similar in tone, these portraits were created for two very different recipients; the one on the left was to be a Valentine's Day gift; the one on the right, believe it or not, was made to commemorate the subject's eighth-grade graduation!

Remember to get input from the parents of the minor when creating their child's portrait. I applied makeup in subdued tones, allowing the client's natural beauty to shine through.

quick reference

CAMERA
Mamiya 645 AFD

LENS
80mm

FILM
Kodak Portra 160NC

APERTURE
f5.6

SHUTTER SPEED
1/60 second

clothing

For me, a white, gauzy dress spells romance. When a client tells me she wants to wear this type of dress in her image, I know just the type of image that will suit her.

Clients sometimes don't realize how special—and personal—a very soft, decidedly feminine image can be.

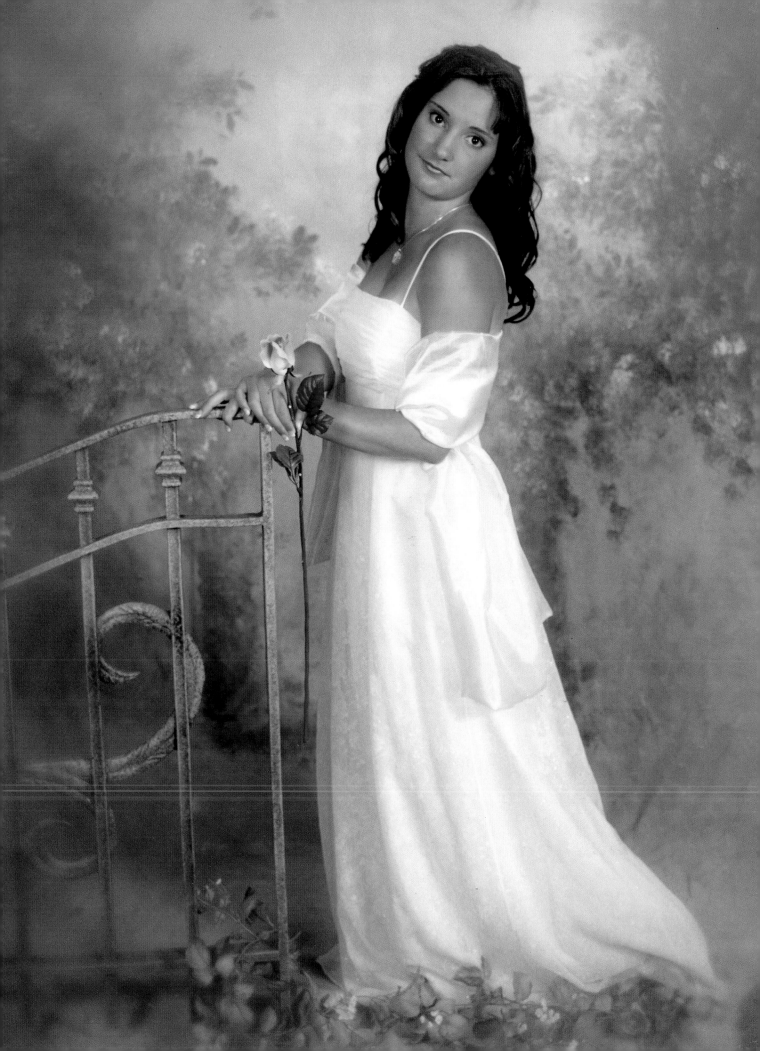

PEACEFUL

teens and seniors

While the majority of my portrait clients are young children, high school seniors also comprise a fairly large percentage of my customer base.

When this stunning teenager arrived at my studio for her senior portraits, I offered to do a complimentary session—if she agreed to let me do it on my own terms.

creating a scene

With my client's consent, I was ready to put my plan in action.

I carefully created an ethereal gown made of carefully wrapped and tucked purple tulle, and hot-glued the berries to the gilded wings. Clusters of grapes and trailing lengths of ivy were added to further illustrate this ethereal, goddess-graced portrait. The scene through my viewfinder looked great—but when the 24x30-inch print was finally delivered, I hated it! The embellishments all of a sudden seemed gaudy.

Having incurred the expense of printing this wall-size image, I wasn't about to admit defeat. Instead, I picked up my paintbrush and began to apply black paint to tone done the harsh colors for a more earthy feel. Now, I'm pleased with the results!

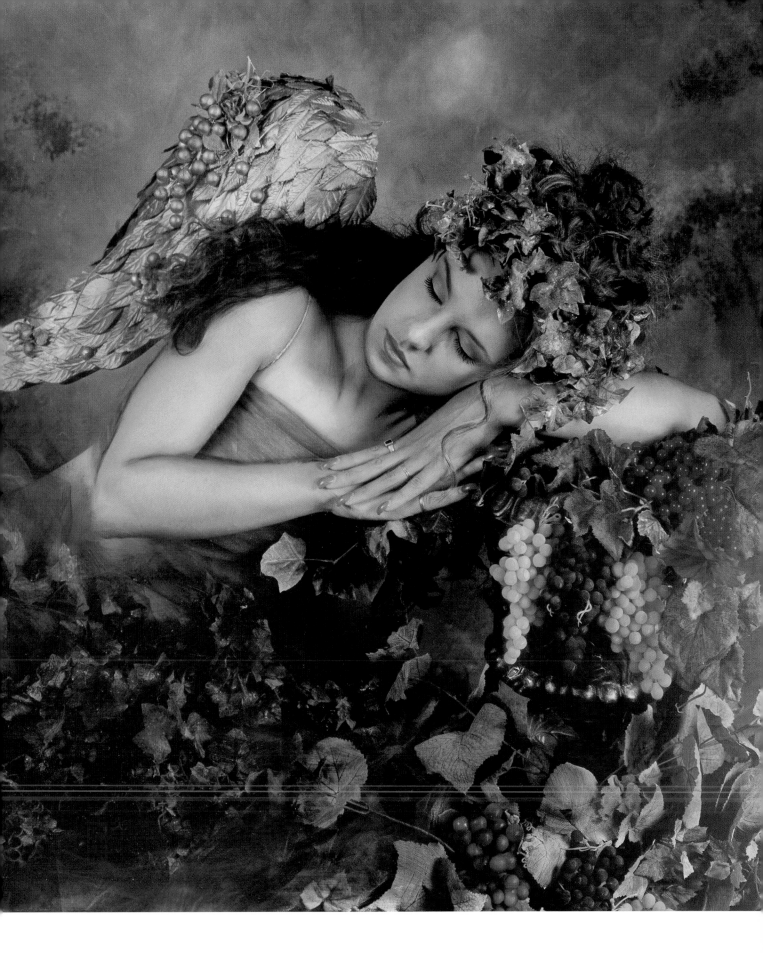

low key portraits

A low key image—one where the majority of the tones in the image are darker than middle gray—really draws attention to the subjects. Here, the baby's white christening gown makes her the focal point of the image. The downward gaze of her siblings serves as an assurance that she is the main subject in this portrait!

A mainstay of low key images, the black backdrop and clothing used in this image proves to show off the dramatic high-

lights, played up with white Marshall Oils, in these children's beautiful light-blond hair.

Just for the record, it is never a good idea to add yellow oils to create highlights in the hair. Start with white oil, then mix another shade in as needed to come up with a natural look. (Incidentally, with the high-

ure to work with, I fine-tuned each subject's position. A triangular composition was created by having the youngest boy lean in, propping himself on his elbows; the older boy leaned in, with his knees bent to both close up the empty space between the subjects and achieve the necessary head height; and the older sister moved in toward the baby to

A low key image really draws attention to the subjects.

lights in place, I brought out the black oil to deepen the shadow areas in the crease of baby's gown.)

composition

To get this shot, I created a large indentation in a beanbag chair, then covered it with dark cloth, making a "nest" for the baby. With the sleeping infant in place and three of the most cooperative and best-behaved clients I've ever had the pleas-

complete the triangle. Finally, I used my hands to perfectly position the youngest boy's head just as I wanted it and, much to my surprise, he didn't move a muscle!

quick reference

CAMERA
Mamiya 645 AFD

LENS
80mm

FILM
Kodak T400CN

APERTURE
f8

SHUTTER SPEED
$^1/_{125}$ second

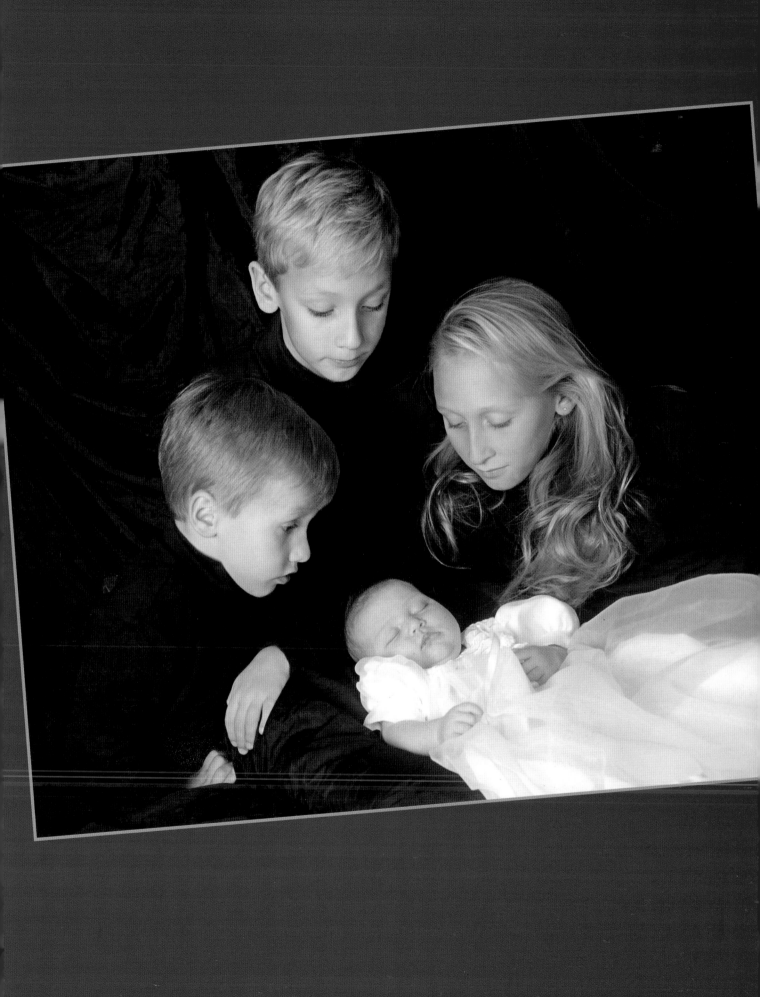

concept

This image is a custom-made revision of a portrait created for an older sibling. To differentiate between the two photographs, however, I added a long-stemmed rose to "feminize" this photo.

the pose

There's something magical in adding adults—albeit often somewhat surreptitiously—to a portrait of an infant or small child. Here, Dad's hands serve as a point of reference in documenting his tiny daughter's

size. But the inclusion of them goes beyond the documentary role; they also serve as a symbolic element in the portrait. If you look intently at the image, you'll find that it conveys much emotion; the image portrays innocence, a sense of frailty, strength, and the importance

guise Dad's shirt sleeves, thus creating tonal harmony in the image. Finally, a section of the fabric was draped over the baby's mid-region.

While it wasn't easy to get Dad's ring finger to show, the wedding ring, in addition to the

The rose was added to "feminize" this photo.

of family—something that would appeal to any client. Imagine the baby positioned against a plain backdrop, without "props"; the resulting portrait simply wouldn't exhibit the emotional impact that this print provides.

clothing

A large bolt of black matte fabric can work magic in the studio. Here, it stars in three important roles. First, and most obviously, it serves as a backdrop. In its less obvious role, the fabric was used to dis-

two subjects and rose, is ultimately a very important part of the image.

quick reference

CAMERA
Mamiya 645 AFD

LENS
80mm

FILM
Kodak T400CN

APERTURE
f8

SHUTTER SPEED
$\frac{1}{60}$ second

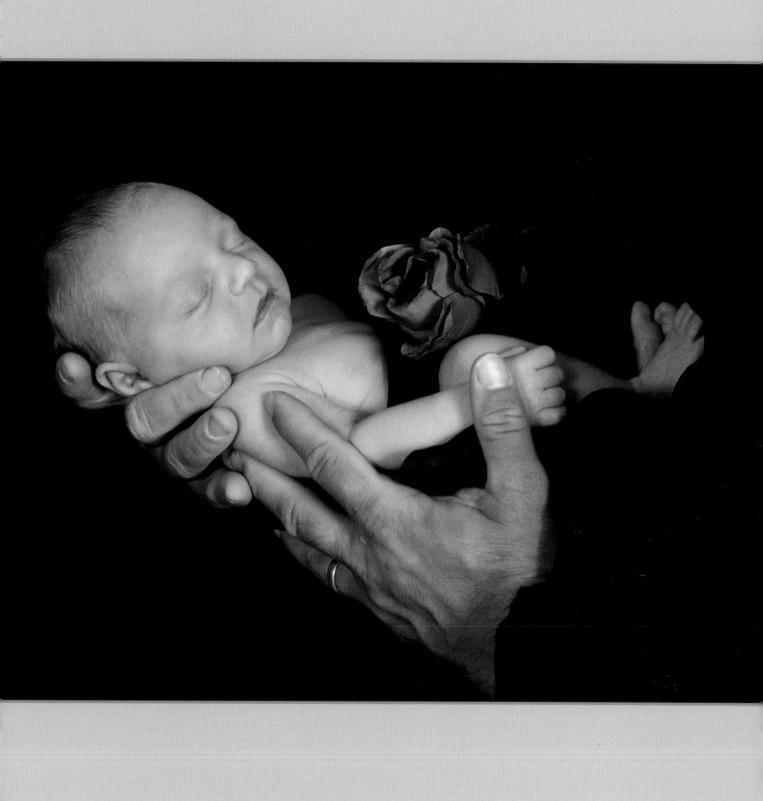

S T A R L E T

teamwork

This remarkably well-behaved three-year-old was definitely a pleasure to work with. She was very cooperative, and together, we turned out a wonderful array of images featuring a wide variety of fabulous poses.

When her grandmother dropped my client off at the studio, then headed out to run some errands, I gave my client the star treatment, adding just a bit of light color to her face to make her feel pampered and using hot rollers to add that voluminous curl. In the end, she felt important and very pretty, and that confidence shows in every image!

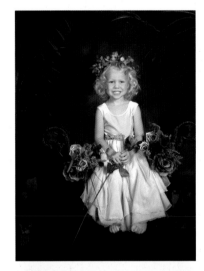

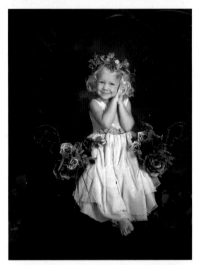

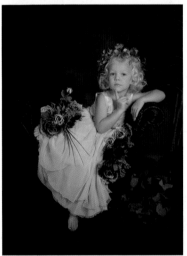

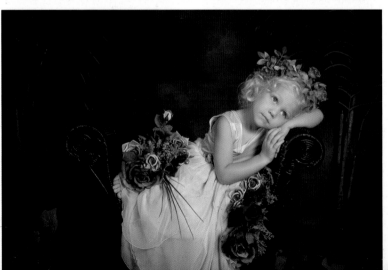

quick reference

CAMERA
Mamiya 645 AFD

LENS
80mm

FILM
Kodak Portra 160NC

APERTURE
f8

SHUTTER SPEED
$\frac{1}{60}$ second

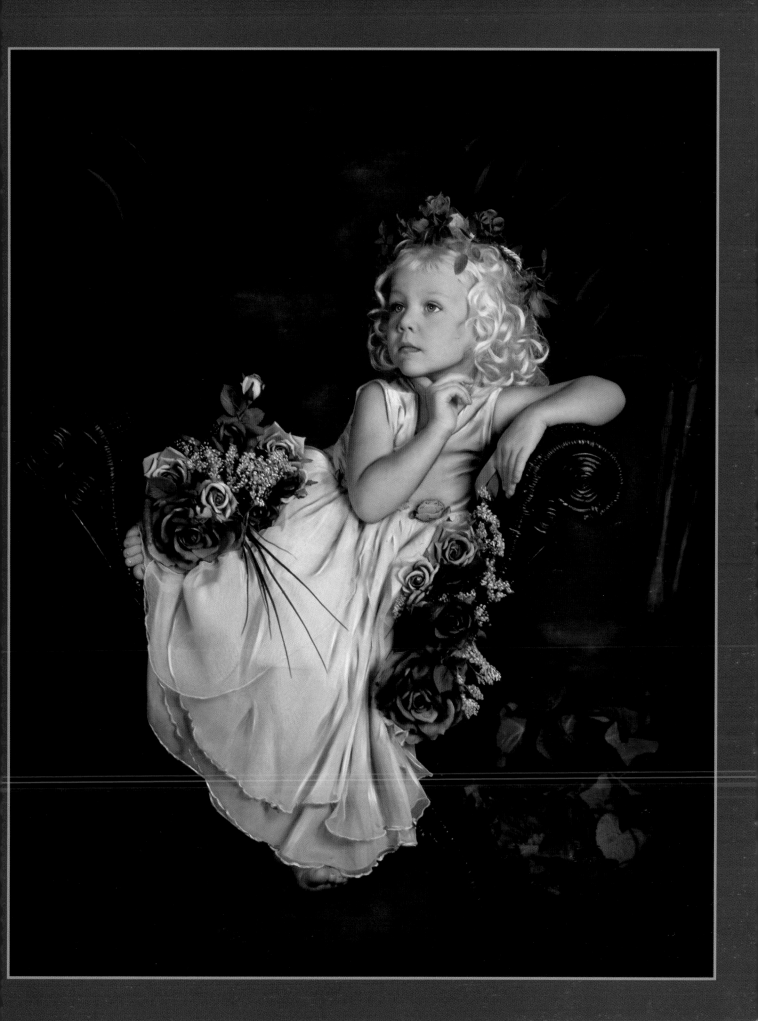

concept

I wish I could take the credit for this image, but it was all the mom's idea. Here, a beanbag chair served as the perfect makeshift posing chair; I simply formed a baby-sized impression in the top, placed an absorbent pad on the chair to safeguard against any accidents, and then covered the ensemble with the much-used black backdrop. Once the baby was coaxed into sleep, we attached a very extravagant ribbon and poignant gift tag, then tucked in the infant's arms and legs for a simple, yet very appealing composition.

special considerations

As I've mentioned, sleeping newborns are wonderful subjects. They stay exactly as you pose them and have mounds of patience. All kidding aside—

We attached a very extravagant ribbon and poignant gift tag . . .

to ensure that the baby stays asleep and that the parent remains relaxed, there are a few simple steps you can take, from turning off the ringer on your telephone, to dimming the lights and turning up the heat—especially when you're planning to capture an image of all of those fabulous little wrinkles!

posing

Here, a beanbag chair was covered with black backdrop material. I formed an indented area in the center of the beanbag and gently laid the sleeping baby down. We tucked in her arms and legs; ultimately, this created a womb-like feeling that would make any infant feel secure.

concept

This dad wanted me to create a portrait of himself and his two boys as a gift to his wife. He felt sure that he wanted a formal portrait, and planned out all of the details—from renting the three tuxedos and the trio of top hats, to picking up the matching sunglasses.

When they arrived at the studio, I shot a series of images in a variety of poses—some with hats, some without. The pose was a lucky break—I was using a narrow backdrop, only 4–5 feet in diameter, which I typically use for business head-shots. Adopting the backdrop for this use meant positioning the clients in profile and moving them in close. While the older boy has an expression that mimics Dad's, the youngest is wearing a satisfied smirk that breaks up the patterns in the image to good effect.

quick reference

CAMERA
Mamiya 645 AFD

LENS
80mm

FILM
Kodak T400CN

APERTURE
f8

SHUTTER SPEED
$\frac{1}{60}$ second

two points of view

When I assemble my proofing folio, I display the top eight images from the session and always place my favorite portrait in the upper left-hand corner. When my client reviews their proofs, I wait for their reaction, especially when their eyes fall on what I perceive is the best image.

As a photographer, you're quick to learn that the images you like best—those that are technically superior or are the result of a special creative departure—are frequently overlooked and undervalued by your client.

It's funny—when you transform a client, capturing on

You will often find that clients favor a more "ordinary" portrayal.

film an artistic interpretation of who they are, you will often find that they favor a more ordinary portrayal of themselves. While I always try to sell the specialness of the results—be it something silly yet classy like the image on the right, or simply stunning in every way (see the image on page 111), I don't always succeed in selling the image. In this case, the customer preferred a more traditional print.

working in pairs

In the top portrait on the facing page, I wanted to capture the strong mother–daughter bond that the clients shared. To enact this for the camera, I simply had the mom cradle her sleeping daughter, who appears to have drifted off to sleep in mid-snuggle. Of course, this tender pose was preconceptualized and then acted out, but it's really quite believable, as both the mother and daughter lack the bodily tension that is sometimes associated with posed images.

quick reference

CAMERA
Mamiya 645 AFD

LENS
80mm

FILM
Kodak T400CN

APERTURE
f8

SHUTTER SPEED
$\frac{1}{60}$ second

To get this image just right, I had the girl practice "sleeping" before she got in front of the camera. During the first trial run, she scrunched up her face and squinted her eyes. With some practice, though,

This unique mat proved to be a great solution!

we were able to achieve a far more believable look!

I used a unique matting style to visually "crop" the mother's hand out of the frame, as it was distracting in the image. While I could have cropped the print itself, doing so would have yielded inappropriate dimensions. Of course, masking the hand digitally would have been more expensive than the matting. In the end, this unique mat pleased the customer, and proved to be a great solution!

The lower image also celebrates the bond between a blond mother–daughter pair. Again, a black background was used to draw focus to the clients' faces.

To light each of these images, I placed one umbrella to camera left and one to camera right. I don't use a background light in a low key image, as I want my client to visually meld into the background, rather than to be clearly separated from it.

As a general rule, I avoid photographing brunettes against a black backdrop. On rare occasions, however, it works. To create the image on page 113, for example, I created separation between the client's dark hair and the black background by skimming light across the topmost area of the client's head.

ALL WOMAN

concept

Years ago, I worked for a high-output glamour photography studio. When I opened my own business, that style was all the rage. I catered to the demand and created glamour and lingerie photos for clients. However, since that time, my style has really evolved. I no longer shoot lingerie photos—but that doesn't mean that I won't shoot sexy images.

Many of my clients are looking for something a little more personal for special occasions like wedding anniversaries, birthdays, and Valentine's Day. When it comes time to discuss the clothing for the shoot, I immediately let them know that they don't need to show a lot of skin to create the kind of

An image like the one pictured here makes for a great gift. . . .

high-impact image they are looking for; after all, a leather jacket, a white tank, a pair of jeans, and boots can be very sexy. With this type of image, you're bound to find a suitable outdoor location in no time at all—no matter your studio's location.

co-ed props

A portrait like the one pictured on the facing page makes for a special gift—especially when the props the women are pictured with have a special meaning for the intended recipient. In this case, the motorcycle was borrowed for the purpose.

Of course, smaller props with some emotional or visual appeal will work just as well.

This photo is displayed in my studio, and the image concept has become very popular with several of my female clients. With the right posing and clothing, it's easy to create a very tough—yet soft—womanly portrait that beautifully showcases your client's multifaceted personality.

lighting

Here, the low angle of the sun and an on-camera flash partnered up for a flattering outdoor image. Using the flash, a Sunpak 555, allowed me to lower the overall contrast in the image and to achieve a very flattering, even lighting quality.

quick reference

CAMERA
Mamiya 645 AFD

LENS
80mm

FILM
Kodak T400CN

APERTURE
f11

SHUTTER SPEED
1/60 second

concept

This image couldn't be simpler, but it really packs a lot of impact. The profile shot was chosen to showcase this client's "state of grace." She is attired only in a black shawl that's strategically covered to show just enough.

making it count

I try to maximize the mom's rounded belly in every maternity pose. I position her in profile and have her arch her back to really emphasize her shape. Of course, getting the client's session scheduled close to the end of her term helps, too! If a client comes in too early in her pregnancy, I'll send her home!

creative controls

Most of my clients look to me for guidance in shaping their portraits. They tell me, "you're the expert . . ." and allow me to create the sort of portrait that I envision. Often, clients have strong ideas about what they want in their image, and while in their mind's eye every detail is perfect, things just don't work out that way on film. Oftentimes, the client who has very strong ideas about the creative aspects of their session just isn't happy with the outcome.

It's my job to make my clients look their best, to study their features, to capture their personalities, and to boost their confidence. Many clients say,

I maximize the mom's rounded belly in every maternity pose.

"I'm not photogenic." I tell them, "If you're not photogenic, that's the fault of the photographer."

No one is more uncomfortable than I am when it comes to getting a picture taken. That's why I dole out a lot of compassion when it comes to my clients' sessions. Turning the nose a quarter-inch, slightly turning the shoulder, having the client tilt her or his chin up, and/or elongating the neck makes all of the difference. I am not a candid photographer, except when I'm using my Nikon at weddings to shoot black & white—then it's more spontaneous than my standard wedding shots. When it comes to straightforward portraiture, I really focus on posing.

quick reference

CAMERA

Mamiya 645 AFD

LENS

80mm

FILM

Kodak T400CN

APERTURE

f5.6

SHUTTER SPEED

$\frac{1}{60}$ second

building confidence

Building a client's confidence is key. If you have an eye for what's beautiful, you can make images that set you apart. All of the technical skill in the world will not save you if you cannot figure out what is beautiful about your client.

Time after time, I have photographed average clients and yielded stunning portraits. Some beautiful clients just don't photograph as well. Beauty is only part of the equation when creating a portrait.

quick reference

CAMERA

Mamiya 645 AFD

LENS

80mm

FILM

Kodak T400CN

APERTURE

f8

SHUTTER SPEED

$\frac{1}{60}$ second

going for glamour

This client was initially photographed by another photographer, and she was unhappy with the results. She was seventeen years old and didn't want an image that made her

This client didn't want an image that made her look like a kid.

look like a kid. When I saw her gorgeous eyes and full, sensuous lips, I knew she'd be a perfect candidate for a 1940s-style glamour portrait.

lighting strategy

Here, two Norman LH4A electronic flashes were placed to camera right. One was fitted with a softbox, and was set to f5.6. The second flash, set to f8, housed a honeycomb grid. To position this light, I pulled it back to achieve the level of diffraction I was after. A honeycomb grid is much like a flashlight: placed too close to the subject, it creates a small cir-

cle of light. By pulling it back, light washed over the client, providing a broader, softer light source. I then coaxed the strong shadows in the collarbone area by angling the grid slightly to the right.

the best laid plans . . .

This client didn't buy this portrait. She ordered some of the "safer" images I created that day—photos that better suited her conception of her "everyday" self. I've often had this experience when a client was "magically" transformed. As an artist, I'm always eager to sell the images that are most artistic, those that really show my clients at their absolute best; my clients sometimes have other ideas.

This was another session in which I had full control over the concept. When my client came in for a consultation, I immediately envisioned what the final image would be like—but I had no idea she would look like Natalie Wood until I gave her an updo.

high impact

Many clients haven't conceptualized the look they are going for when they first arrive at my studio. All they know for certain is that they want their picture taken.

While I used to display albums filled with 8x10-inch prints in

I had no idea she would look like Natalie Wood. . . .

order to familiarize clients with the artistic options available to them—from props, to lighting styles, to posing, to the hand-painting effects—I have since discovered a more viable alternative. In a nutshell, I've learned to "show big."

The smallest prints hanging on my walls are 11x14 inches; the largest are 30x40 inches. Now, when the client walks into the room, they not only see what I can do and the options that are available, but they also experience the "wow" factor. They don't sit down with an album filled with comparably small photos. Instead, they see some of my best work in the form of beautiful, framed, wall-size portraits adorning the walls of my studio. This way, the client

is immediately exposed to the impact that large photos will have in their homes. Suddenly, anything smaller seems somewhat less appealing.

This strategy works on two important levels: it creates a springboard that allows us to begin to develop a portrait concept and creates an emotional connection with the high-impact larger portraits. Needless to say, this is a great marketing tool as well.

lighting

High contrast equals high drama in this glamour portrait. Split lighting was used to effectively flatter the subject's features. To achieve the look, my softbox was placed to camera right so that it skimmed the bridge of the client's nose and lit only the far side of her face. The result was a sultry, high-style image.

hands-on

I handle each and every aspect of my business, from booking appointments, to shopping for props, to cleaning the studio. That's the way I like it. I can't release responsibility to anyone else, because it's my name that appears on the final print. I wouldn't think of hiring someone to sit at my desk and talk about clothing and background selection, then write up notes about a pending session on a little piece of paper.

I never want to walk into my camera room to find a stranger waiting for their session. I need to know who they are and how they envision their final image. Are they looking for black & white, a sepia tone, or color, or for outdoor, formal, or casual shots? It's important that the client gets what she or he wants, because my goal is to have a wall-size portrait hanging in their home—not an 8x10-inch print.

quick reference

CAMERA

Mamiya 645 AFD

LENS

80mm

FILM

Kodak T400CN

APERTURE

f8

SHUTTER SPEED

$\frac{1}{60}$ second

People often tell me that I'd make more money in a big city. Sure, that's true. But I don't

People often tell me that I'd make more money in a big city.

want to run a studio that runs through twenty sessions per day. I don't want to sign my name to portraits created by another photographer; they wouldn't be my photographs, and I would no longer have complete artistic control.

Friends and clients have also urged me to open a second studio. However, I've built a very successful business based on the personal attention that each client receives. If I spread myself too thin, my ideals and the philosophies that I've built my business on would eventually be negated.

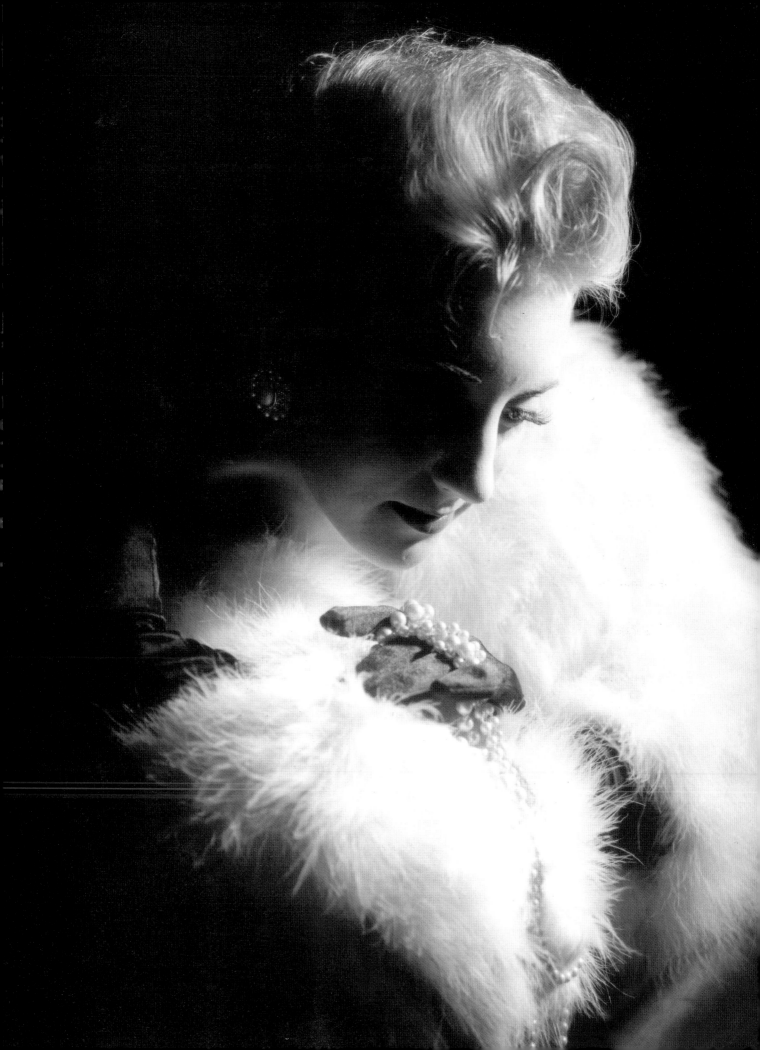

This on-location portrait was created as part of a package for a high school senior.

Here, with the natural light modified beautifully by the overhanging branches and lingering autumn leaves, I set my on-camera flash to f5.6 and used an exposure of f8 at $\frac{1}{60}$.

marketing

Running a small-town studio has its advantages. Most of my customers find out about my work through word of mouth. My portraits are on everyone's walls in this small town. In fact, the glamour portraits I took twelve years ago are still on display in people's houses! When they come back to the

Running a small-town studio has its advantages.

studio, they are surprised at how my work has changed.

When I first opened my doors, I was a little concerned that, operating in a small town of 30,000 people, I would have booked sessions with absolutely everyone who wanted a portrait in a matter of just a few years. Well, those clients who came to me twelve years ago for those early glamour shots have come back for their wedding images, then for pictures of their babies and for family portraits. I'm happy with the arrangement—I enjoy working with these clients and truly thrive on establishing lasting client relationships.

I do a little bit of newspaper advertising and donate gift certificates to many of the businesses in town. In addition to word-of-mouth advertising, this draws all of the clients I need to achieve the income necessary to live the lifestyle I desire.

quick reference

CAMERA

Mamiya 645 AFD

LENS

80mm

FILM

Kodak T400CN

APERTURE

f8

SHUTTER SPEED

$\frac{1}{60}$ second

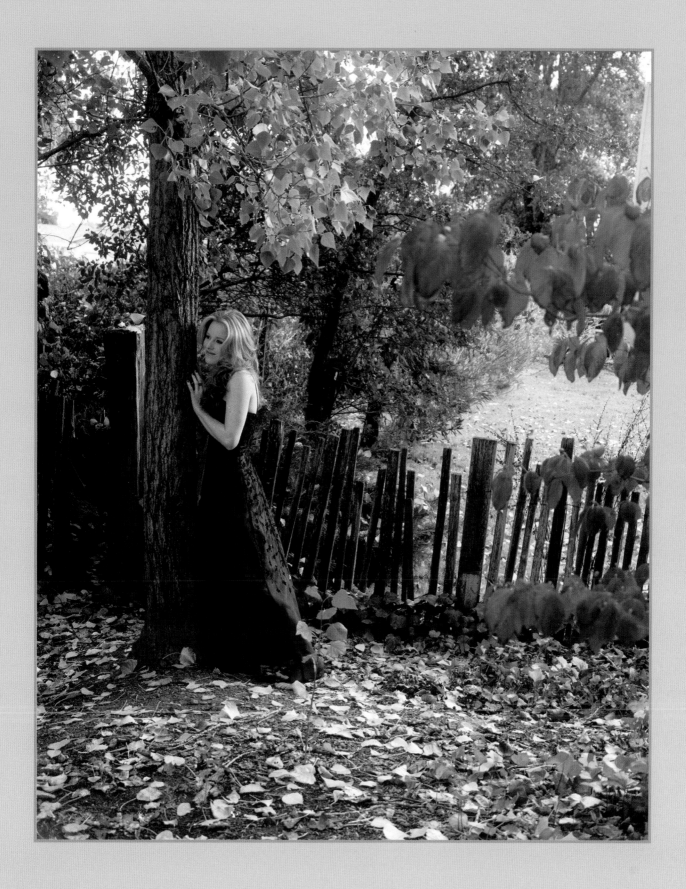

MOST PHOTOGENIC

This exceptionally photogenic client's session came together beautifully. The clothing selected for the session and the poses I coaxed her into were perfectly suited to a 1940s-style glamour portrait.

a glowing review

To produce the beautiful skin tones in these images, I placed two electronic flashes at camera right. Again, one was fitted with a softbox, and the one closest to the subject was fitted with a honeycomb grid. While using a grid can help you to accomplish stunning results, it is very difficult to fine-tune the light each time your subject moves. In truth, simply opening up your aperture one to two stops over the metered reading will produce similar results in the skin tones—with much less difficulty.

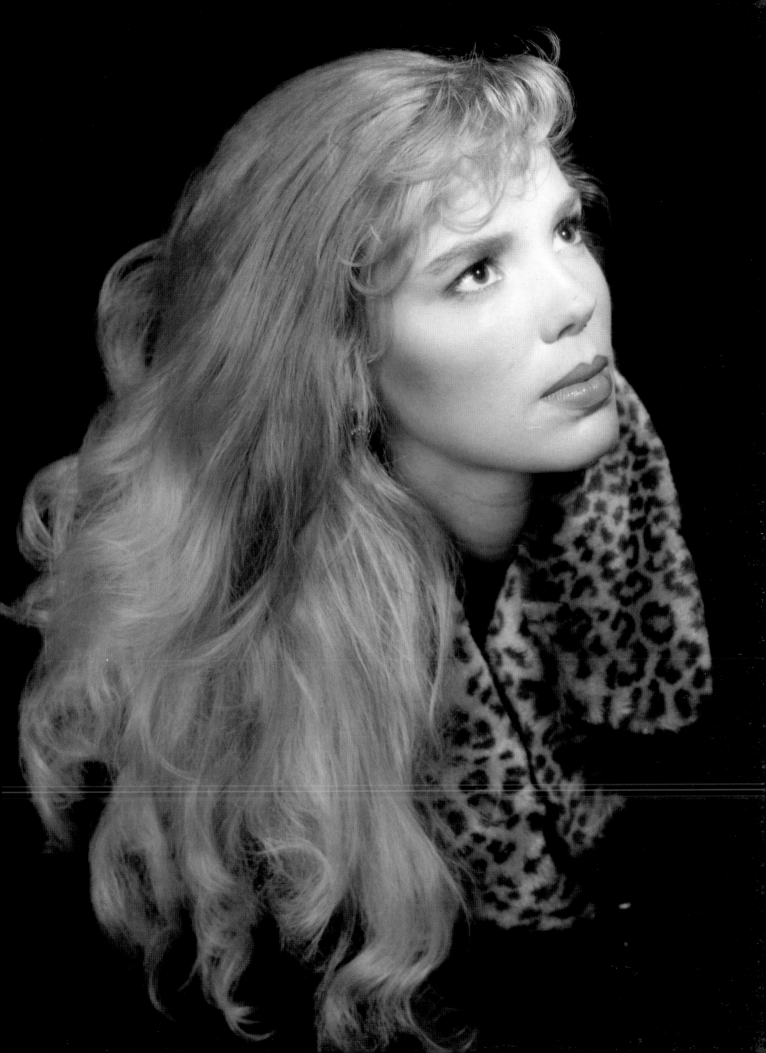

Photographing blonds against a black background is especially flattering. Here, the client's light hair and fair skin seem to jump from the background. The polka dots and silky texture of the dress and the straw hat, though largely monochromatic, separate nicely from her ink-black surroundings.

The pose created for this image is full of dynamic lines that create visual interest in the image. Notice the way that the client's hand position forms a leading line that draws the viewer in to examine the subject's cool expression. The downturned gaze of the client and the directional quality of the vibrant yellow rose highlight the quiet, high-style mood of the image and ensure that the viewer's attention won't stray far from the subject's face.

lighting

To effectively light this elegant, fashion-type portrait, I used two LH4As softboxes, each placed below the brim height of the client's hat and 45 degrees to either side of the camera. The directional lighting produced by the softboxes beautifully rendered the client's fair, porcelain-like complexion.

In creating this image, I chose to stray from my generally preferred aperture of f5.6, as f8 allowed me to capture both her face and the wide brim of her hat in sharp focus.

quick reference

CAMERA
Mamiya 645 AFD

LENS
80mm

FILM
Kodak T400CN

APERTURE
f8

SHUTTER SPEED
1/60 second

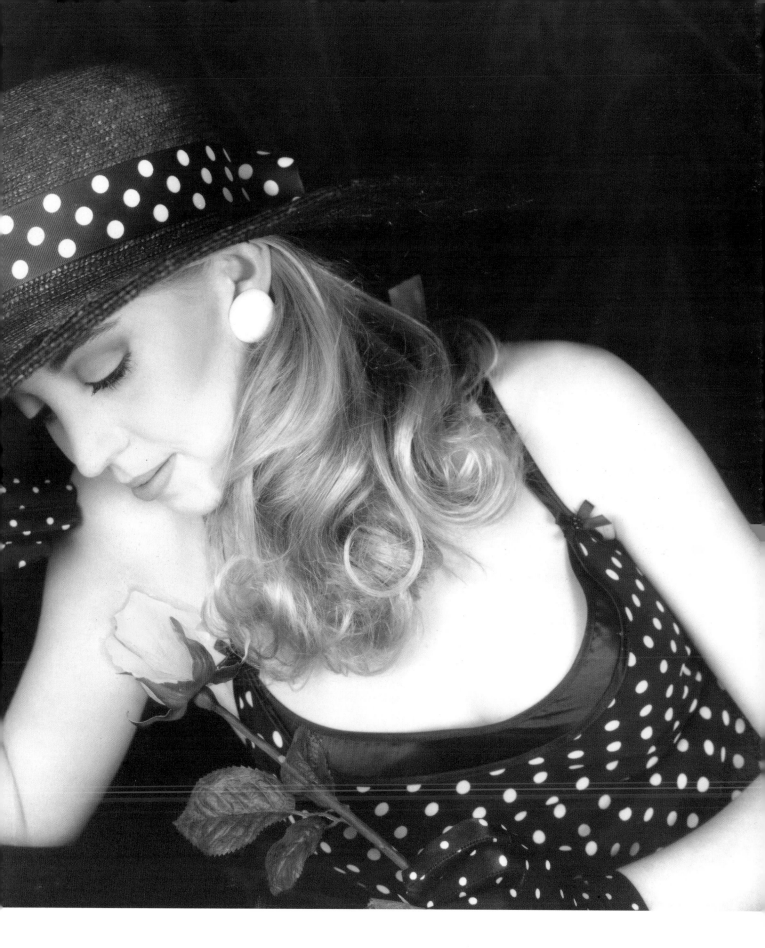

surely scenic

This image proves beyond the shadow of a doubt that everyday backgrounds can be flat-out extraordinary. If you can train yourself to see only what your lens sees (see page 16), you'll have a great number of fabulous backgrounds at your disposal.

The client shown here is actually sandwiched between a bank's night depository and a sign posting the bank's hours. Of course, viewers don't see the distractions that lie outside of the image frame. Instead, they see only stately columns that seem to perfectly compliment my client's classic beauty.

traveling light

This portrait was made in open shade. I used an incident meter

to measure the light falling on the scene and used a silver reflector to be doubly sure that my client's face was properly illuminated, eliminating any possibility of shadows.

I use a four-in-one reflector panel manufactured by Photoflex. Featuring a black, silver, gold, and white panel, this reflector allows you to easily transform a single panel into precisely the right tool—be it reflector or gobo—for the job.

While many photographers like to use a gold reflector when shooting outdoors, I feel that silver reflectors produce a more natural look, which can always be warmed up slightly at the lab.

While my camera of choice is the Mamiya 645 AFD, I also

Everyday backgrounds can be flat-out extraordinary.

carry a backup medium format camera—the Mamiya 645 Pro—to each location setting. I also bring my 35mm Nikon N90S, loaded with black & white film when creating a session on location.

I used my 35mm Nikon to create this outdoor portrait. When the relatively small 35mm negative was enlarged to produce a big 16x20-inch print, we achieved a stunning, heavily grained image.

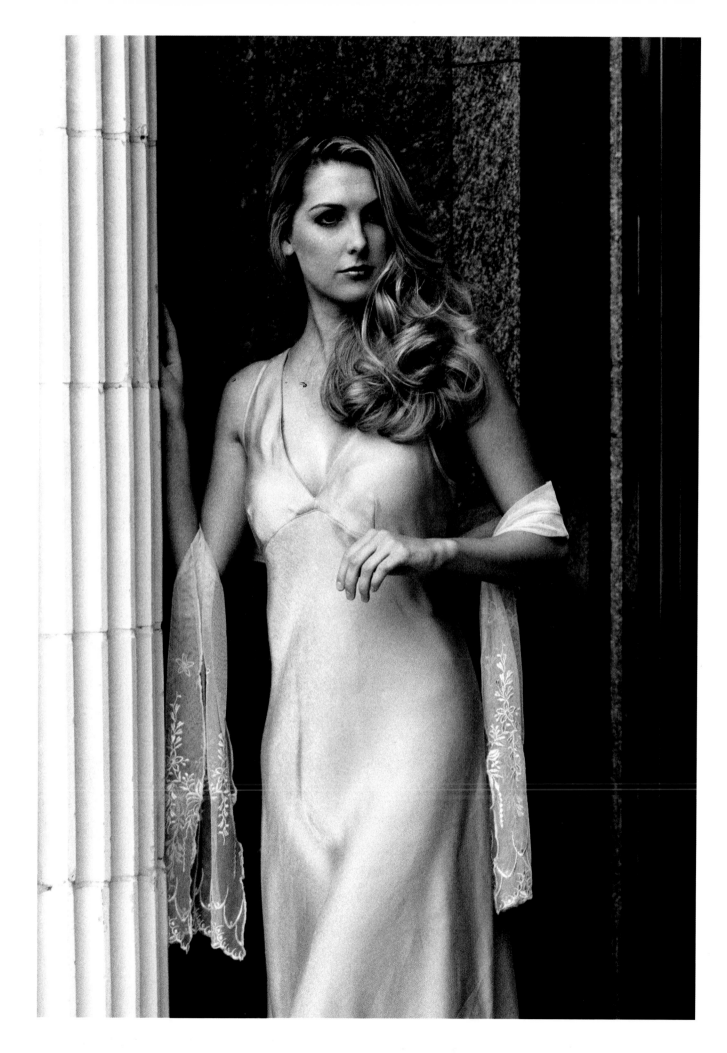

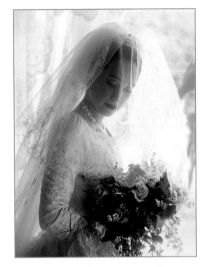

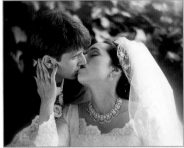

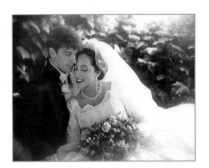

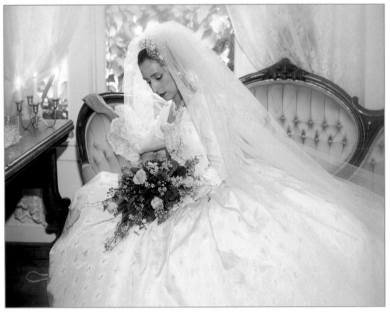

Each of these images was made with window light. Window light has a wonderful no-frills quality that some clients prefer to studio lighting. It's especially flattering for wedding images like these.

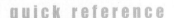

quick reference

CAMERA

Mamiya 645 AFD

LENS

80mm

FILM

Kodak T400CN

APERTURE

f5.6–f11

SHUTTER SPEED

$\frac{1}{60}$ second

Today, storytelling images are more popular than ever. They go beyond the staid, traditional images that were once the only portrait type available to couples. I think these photojournalistic portraits better capture the mood of the day. Of course, black & white film and sepia tones help to make an image seem timeless as well.

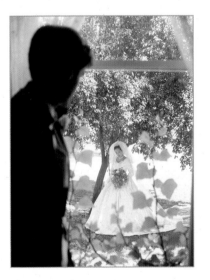

index